IMAGES
of America

SEATTLE'S
HISTORIC RESTAURANTS

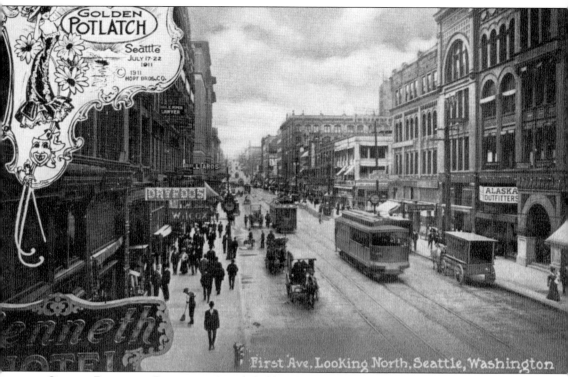

GOLDEN POTLATCH POSTCARD. Seattle held its first Golden Potlatch July 17–22, 1911. The word "potlatch" is from the Chinook jargon, the trade language of the North Pacific Coast Indians. Potlach means a gift, or to give. In a larger sense, the Native Americans applied it to a great festival at which gifts were made. More than 300,000 people have visited Seattle for this citywide celebration of parades, concerts, and activities. (Author's collection.)

ON THE COVER: Women eat at the Georgian Room in the Olympic Hotel in Seattle in 1948. This world-class hotel, which has enchanted guests since 1924, sits on the original site of Territorial University, now the University of Washington. This five-star hotel has played host to presidents, entertainers, and royalty, delivering luxury in a timeless style. (Courtesy of *Seattle Post-Intelligencer* Collection, Museum of History and Industry, No. 1986.5.9615.)

IMAGES
of America

SEATTLE'S
HISTORIC RESTAURANTS

Robin Shannon

ARCADIA
PUBLISHING

Published by Arcadia Publishing
Charleston SC, Chicago IL, Portsmouth NH, San Francisco CA

Printed in the United States of America

Library of Congress Catalog Card Number: 2008926297

For all general information contact Arcadia Publishing at:
Telephone 843-853-2070
Fax 843-853-0044
E-mail sales@arcadiapublishing.com
For customer service and orders:
Toll-Free 1-888-313-2665

Visit us on the Internet at www.arcadiapublishing.com

To Jeremy, my son, for without him this life would not be worth living.
I love you, more, more, more.

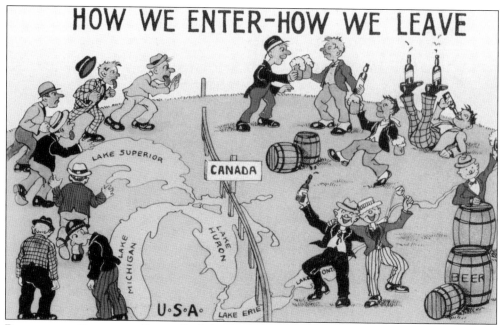

PROHIBITION POSTCARD. During Prohibition in Seattle, from 1916 to 1933, many people took a road trip north to Canada to load up on liquor. In 1933, Gov. Clarence Martin advised the establishment of a state monopoly on the sale of hard liquors and the licensing of beer and wine sales. The Washington State Legislature approved this act, and the Liquor Control Board was created. (Author's collection.)

CONTENTS

ACKNOWLEDGMENTS

Projects such as these have contributions from a plethora of places and people. A great gratitude and recognition goes to several people and places, including the Museum of History and Industry, particularly Carolyn Marr; the Seattle Municipal Archives, particularly Jeff Ware; the Shoreline Historical Society, particularly Vicki Stiles; HistoryLink; Laurie ValBush, my friend and personal editor; the Pacific Northwest Postcard Club; Canlis, particularly Rachel Lund; the Southwest Seattle Historical Society, particularly Alan Peterson; Everett Public Library, particularly Margaret Riddle; and Julie Albright, my friend and editor from Arcadia.

I am so glad to have taken on this project because I have worked in so many restaurants in my lifetime, such as Sambos, Lil Jon's, Black Angus, Barnaby's, Kirkland Roaster and Ale House, Snoqualmie Falls Lodge, and the Salish Lodge. Currently, my job allows me to travel and eat in marvelous restaurants all over the United States—much more enjoyable than having to slave in them. Over the years, I have collected quite a few menus. I would like to hear from the readers if they would like to contribute some memorabilia to the subject, or would like to recommend a restaurant for a possible future publication. Enjoy!

INTRODUCTION

Seattle voters approved a statewide prohibition law by 61 percent in 1914. In Washington State, from 1916 to 1933, Prohibition outlawed the manufacture, transportation, and sale of alcoholic beverages.

On January 1, 1916, Washington State joined 18 other dry states in prohibiting the sale of intoxicating liquor. The closed saloon signs said everything: "Died December 31, 1915," "Gone but Not Soon to Be Forgotten," "Stock Closed Out—Nothing Left," "A Happy and Dry New Year," and "Closed to Open Soon as a Soft Drink Emporium."

This new law closed breweries and saloons, but it permitted private citizens to acquire permits from county auditors to import 12 quarts of beer or two quarts of hard liquor every 20 days.

A "bone dry" Prohibition amendment of the U.S. Constitution was passed in 1919, which then prohibited all liquor sales, manufacturing, and transportation, excluding druggists, in the United States.

The biggest bootlegger during Seattle's "dry" years of the 1920s was Roy Olmstead. The 18th amendment that prohibited intoxicating liquor backfired; it spawned more corruption and lawlessness instead of diminishing them.

On December 5, 1933, Prohibition was repealed with the 21st amendment to the U.S. Constitution. The manufacture, transportation, and sale of alcoholic beverages were no longer illegal, and the Seattle City Council enacted an emergency ordinance allowing the sale of wine and beer.

Seattle was calm on the first night of legal liquor. R. B. Berman, a reporter for the *Seattle Post-Intelligencer*, wrote on December 6, 1933: "You walked into a bar on lower 3rd Ave. There were nine people in the place. A venerable bartender stood with folded arms, looking at the wallpaper. 'Brandy and soda? Yessir. No, the crowd's nothing extra tonight. In fact, it's very slow tonight. Must be the rain.'"

Blue laws in Washington State stated that taverns could only sell beer and wine, and hard liquor could not be sold. Additionally, liquor sales were forbidden on Sundays. Beer and wine could also be bought at the local grocery store. Washington State retains a monopoly on sales of hard liquor to this date. However, hard liquor can now be bought on Sundays, and taverns can now sell hard drinks if licensed.

Following the Depression, nearly everyone ate at home. In 1949, liquor by the drink became legal, which took cocktails out of private clubs and started the modern-day era of restaurants in Washington State. Elegant restaurants started serving liquor coupled with expensive dinners, creating a higher profit margin.

Many restaurants featured broiled meats. Andy's Diner had a charcoal broiler that was the heart of the dining room. Canlis has been serving steaks from its charcoal broiler for 58 years. Canlis was also the first Northwest restaurant to feature an open charcoal grill where guests could watch chefs grilling prime, Midwest, dry-aged steaks; king salmon; and fresh Pacific mahimahi over Kiawe charcoal brought in from Hawaii. El Gaucho was and still is a nostalgic dining experience where steaks and seafood are broiled on a bed of coals. Pancho's served "From the Live Charcoal

Broiler." Garski's Scarlett Tree served a sumptuous broiled lobster tail costing $2.75 from its broiler. Others that jumped on the bandwagon were Les Brainard's new Grove restaurant, Clark's Crabapple, Clark's Totem Café, and Clark's Windjammer.

The 1950s were a busy time that saw a boom of local fast food places. In the 1960s, chain restaurants popped up. Then in the 1970s, there were tons of new restaurants to choose from. Many restaurants have come and gone, and a few have stood the test of time. Fredericks Tea Room might be gone, but the Empress Hotel in Vancouver still serves an afternoon tea service. No roads lead to the Dog House, but the Space Needle still revolves in the sky. The Jolly Roger has been torn down, but the elegance of Canlis still leaves one breathless. The Snoqualmie Falls Lodge no longer has that country feel but has been transformed into the sophisticated Salish Lodge. Ivar's is still Ivar's. One can still order a fine cocktail at these places, but it will cost a bit more.

One

SEATTLE AREA'S
OLDEST CAFÉS

Early structures in downtown Seattle were typically wooden and nearly all burned to the ground in the great Seattle Fire of 1889. Built after the fire, the Merchant's Café, considered the oldest standing restaurant in Seattle, has been in almost continuous use since its founding in 1890. In its 118 years of operation in Pioneer Square, it has survived riots, numerous earthquakes, and a somewhat sordid history. HistoryLink.org reports that there were 92 restaurants in Seattle in 1900. Early 1900 families ate their meals at home, while single men on their way to the gold fields would spend their money and time hanging around in the local bars and cafés.

Featured in this chapter, the 1908 Royal Bar and Café was located on First Avenue in downtown Seattle and gives the readers a glimpse of early city life. Several cafés like the 1910 Gerald's Café, located in the Coleman Building, and the 1910 Spier Caféteria, where the Norton Building is now, are covered in this chapter. The Bessie B. Waffle Shop had a huge clientele that followed the business from place to place. While these are older places of business few will remember, they are of historic value. Merchant's Café is still open; have you eaten there? While many travel Snoqualmie Pass, how many know that there was once a 1920s restaurant at Denny Creek?

MERCHANT'S CAFÉ. This *c.* 1911 photograph of Pioneer Square shows the Merchant's Café, the oldest almost continually serving restaurant since 1890 in Seattle. Known as the Sanderson Block, the building was designed by W. E. Boone and was built right after the fire of 1889. (Courtesy of PEMCO Webster and Stevens Collection, MOHAI, No. 1983.10.8056.2.)

BOARD AND LODGING RESTAURANT. R. King and D. W. Baskerville took this photograph in 1892 showing frontier and pioneer life in Snohomish County. (Courtesy of the Everett Public Library.)

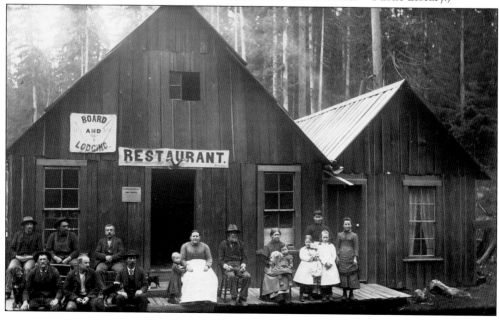

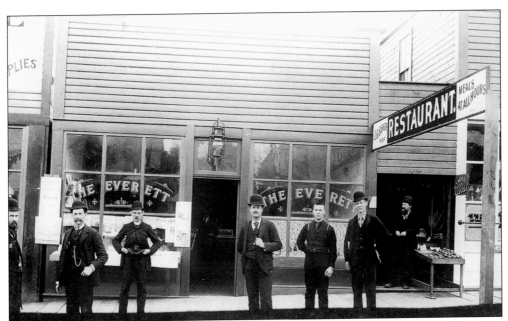

THE EVERETT RESTAURANT. This photograph shows the Everett short-order restaurant on Hewitt Avenue near Chestnut Street in Everett. R. King and D. W. Baskerville snapped this shot on May 10, 1892. (Courtesy of the Everett Public Library, No. 0740.)

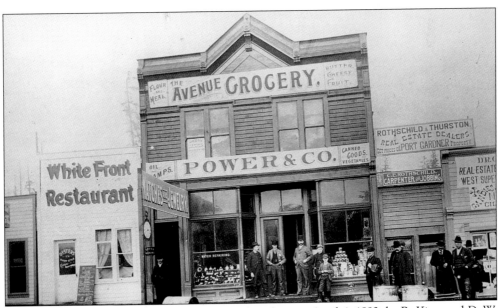

WHITE FRONT RESTAURANT. This photograph, taken on April 4, 1892, by R. King and D. W. Baskerville, shows the White Front Restaurant and Power's Avenue Grocery on Hewitt Avenue between Walnut and Chestnut Streets in Everett. (Courtesy of the Everett Public Library, No. 0719.)

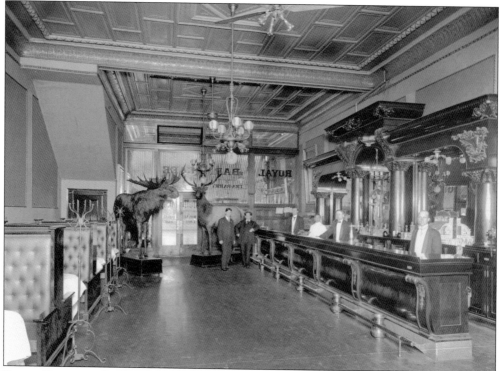

ROYAL BAR AND CAFÉ. This *c.* 1908 photograph was taken by Webster and Stevens of the Royal Bar and Café interior. The Royal Bar and Café was listed at 818 First Avenue. (Courtesy of PEMCO Webster and Stevens Collection, MOHAI, No. 1983.10.7636.)

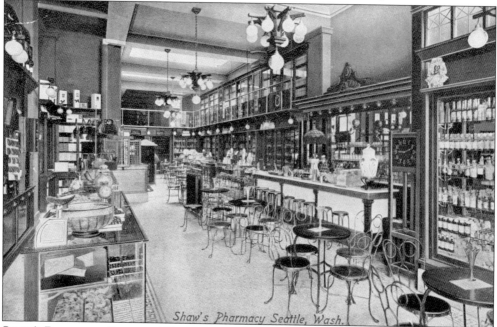

SHAW'S PHARMACY SEATTLE. This postcard, postmarked on May 11, 1908, was sent to Mary Le Sourd in Salt Lake City, Utah. (Author's collection.)

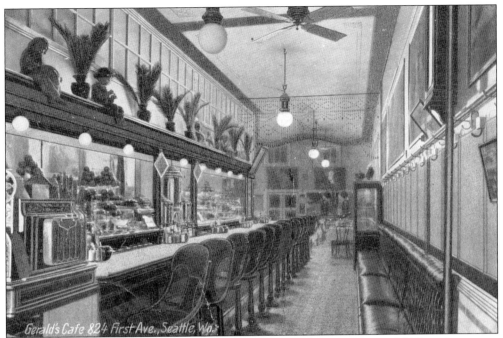

GERALD'S CAFÉ. Gerald's Café was located inside the Colman Building at 824 First Avenue, as this *c.* 1909 postcard shows. (Author's collection.)

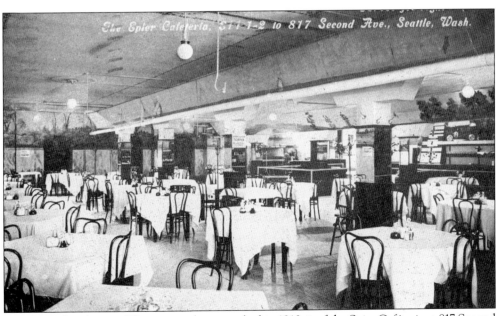

THE SPIER CAFÉTERIA. This postcard, postmarked in 1910, is of the Spier Caféteria at 817 Second Avenue, where the Norton Building now stands. (Courtesy of Janey Elliott.)

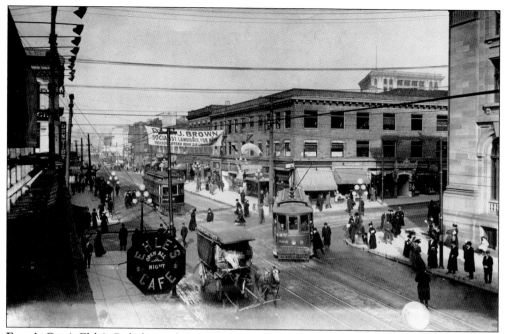

EHLE'S CAFÉ. Ehle's Café, located at the corner of Third Avenue and Union Street, was open all night. This *c.* 1911 photograph, with a banner promoting Dr. E. J. Brown as the Socialist candidate for mayor, shows early Seattle. (Courtesy of the Seattle Municipal Archives, No. 66237.)

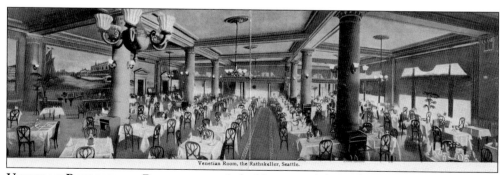

VENETIAN ROOM AT THE RATHSKELLER. A double postcard shows the Venetian Room located at the Rathskeller on Second Avenue in Seattle. The back of this postcard showed what was happening at Prior's Orchestra the week of July 15, 1912. (Courtesy of John Cooper.)

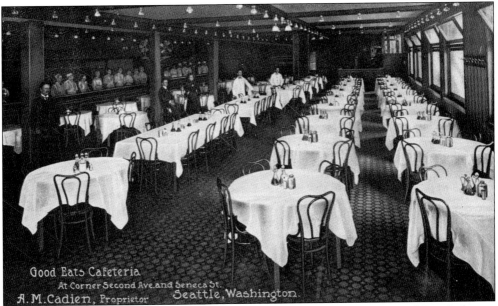

GOOD EATS CAFÉTERIA. Pictured above is a postcard of the interior of the Good Eats Caféteria, which was located at the corner of Second Avenue and Seneca Street. A. M. Cadien was the proprietor. In 1914, there was also a Good Eats Caféteria located at First Avenue and Cherry Street. (Courtesy of Janey Elliott.)

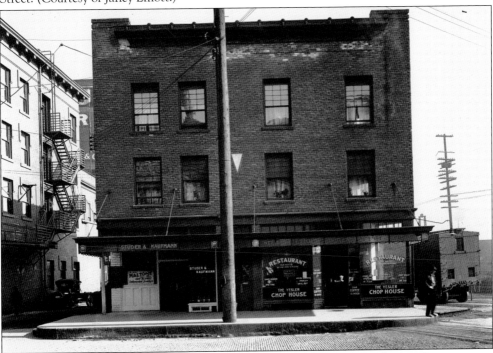

THE YESLER CHOP HOUSE. This photograph was taken on June 13, 1916, by the Seattle engineering department of Studer and Kaufman's restaurant, the Yesler Chop House. Signs in the photograph include: "Our coffee is Good," "Our Motto, We Are Here To Please," "Short Orders At Any Time," and "Special Dinners From 11:00 Until Out." (Courtesy of the Seattle Municipal Archives, No. 1051.)

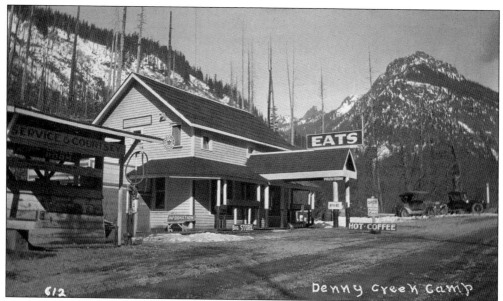

RESTAURANT AT DENNY CREEK CAMP. This 1920s photograph of the gas station and restaurant at Denny Creek Camp at Snoqualmie Pass was made for the Juleen postcard series. (Courtesy of the Everett Public Library, No. J612.)

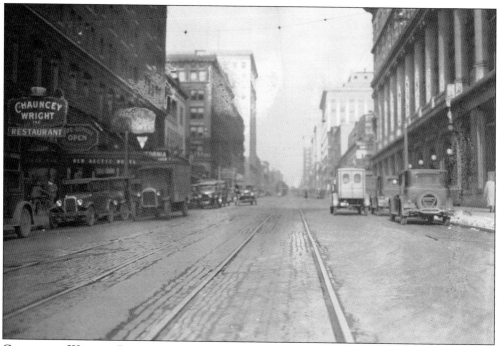

CHAUNCEY WRIGHT RESTAURANT. This photograph was taken from Third Avenue looking north from Jefferson Street on November 3, 1928. It shows the Chauncey Wright Restaurant on the left side of the street. On the menu were many items promised as "always ready," and the fact that the restaurant had its own cold-storage plant insured that the meats were kept at the proper temperature. (Courtesy of the Seattle Municipal Archives, No. 3030.)

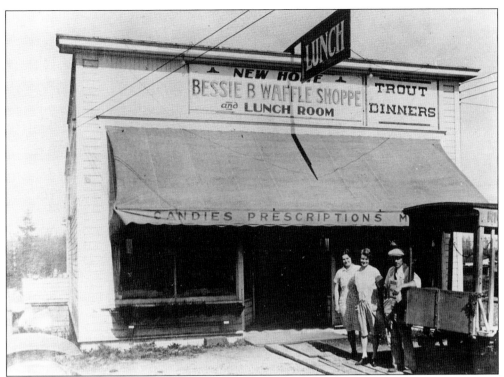

BESSIE B. WAFFLE SHOPPE. The Bessie B. Waffle Shoppe and Lunch Room was located on Firlands Way in Shoreline from 1928 to 1932. Shown here from left to right are Bessie B. Haines, Laura Watts, and Sam Christensen. Christensen owned the Richmond Highlands dairy, and his delivery wagon is shown in the photograph. (Courtesy of the Shoreline Historical Museum, No. 279.)

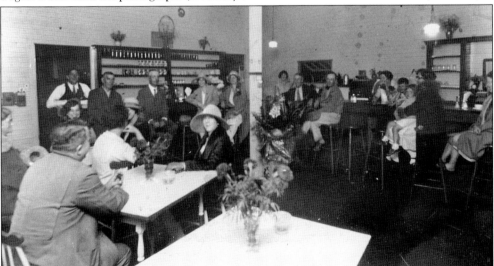

BESSIE B. WAFFLE SHOPPE INTERIOR. This 1930 photograph shows an inside view of the Bessie B. Waffle Shoppe. At the table are Herb and Ruth Smith, Mrs. Fisher, Clara Granston, and Esther Fisher. At the back are Roy Haines, George Kerkov, Fred Hite, two unidentified, Alice Willets (waitress), Jack Barkley, unidentified, Bessie B. Haines, her son Herb Haines, Mrs. Barkley and her daughter Laura Watts. (Courtesy of the Shoreline Historical Museum, No. 262.)

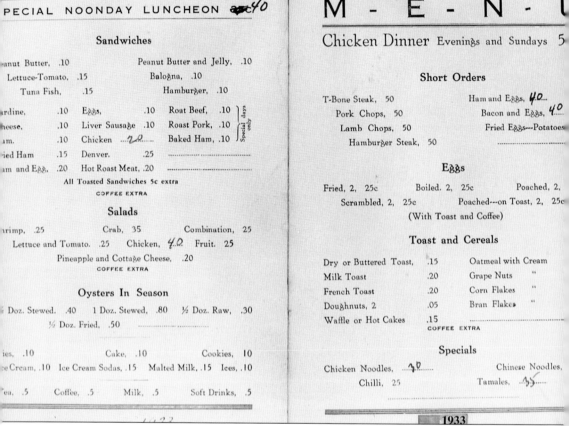

SPECIAL NOONDAY LUNCHEON 40

Sandwiches

Peanut Butter, .10		Peanut Butter and Jelly, .10
Lettuce-Tomato, .15		Balogna, .10
Tuna Fish, .15		Hamburger, .10

Sardine, .10	Eggs, .10	Roat Beef, .10
Cheese, .10	Liver Sausage .10	Roast Pork, .10
Ham, .10	Chicken .20	Baked Ham, .10
Fried Ham .15	Denver, .25	
Ham and Egg, .20	Hot Roast Meat, .20	

Special days only

All Toasted Sandwiches 5c extra

COFFEE EXTRA

Salads

Shrimp, .25	Crab, 35	Combination, 25
Lettuce and Tomato. .25	Chicken, 40	Fruit. 25
Pineapple and Cottage Cheese, .20		

COFFEE EXTRA

Oysters In Season

½ Doz. Stewed. .40	1 Doz. Stewed, .80	½ Doz. Raw, .30
½ Doz. Fried, .50		

Pies, .10	Cake, .10	Cookies, 10	
Ice Cream, .10	Ice Cream Sodas, .15	Malted Milk, .15	Ices, .10
Tea, .5	Coffee, .5	Milk, .5	Soft Drinks, .5

M - E - N - U

Chicken Dinner Evenings and Sundays 5

Short Orders

T-Bone Steak, 50	Ham and Eggs, 40
Pork Chops, 50	Bacon and Eggs, 40
Lamb Chops, 50	Fried Eggs---Potatoes
Hamburger Steak, 50	

Eggs

Fried, 2, 25c	Boiled. 2, 25c	Poached, 2,
Scrambled, 2, 25c	Poached---on Toast, 2, 25c	

(With Toast and Coffee)

Toast and Cereals

Dry or Buttered Toast,	.15	Oatmeal with Cream
Milk Toast	.20	Grape Nuts "
French Toast	.20	Corn Flakes "
Doughnuts, 2	.05	Bran Flakes "
Waffle or Hot Cakes	.15	

COFFEE EXTRA

Specials

Chicken Noodles, 40	Chinese Noodles,
Chilli, 25	Tamales, 35

1933

BESSIE B. WAFFLE SHOPPE MENU. The Bessie B. Waffle Shoppe and Lunch Room menu from 1933 is shown here. The menu was created without some prices. The shop owners later moved the business to Aurora Avenue North and North 184th Street. (Courtesy of the Shoreline Historical Museum, No. 271.)

Two

TAKE ME AWAY

Take me away to another land, another place, and help me forget my troubles. There seemed to be a huge push in exotic restaurants in the 1950s and 1960s.

Approximately 128 years ago, many Chinese came to the Pacific Northwest to work on the railroad. When the construction of the railroad was completed, the labor force was discontinued. In spite of being paid less than the going rate, the Chinese worked for as much as they could get. No one ever asked them to join any labor organization. "Americanized" Chinese food was flavorsome and inexpensive, so a number of Chinese American restaurants sprang up in Seattle.

Ruby Chow's Chinese Restaurant employed Bruce Lee in 1959, when he moved to Seattle to attend the University of Washington.

Trader Vic's South Seas atmosphere first hit the Seattle scene in 1949, where it opened in the Westin Hotel. Trader Vic's was the place to dine and dress to the nines. It rated right up there with Canlis and Rossellini's. This restaurant can still be visited around the world, including in international destinations such as Bangkok, Dubai, London, and Munich. Bellevue is the 24th Trader Vic's location.

Roy Seko introduced Bush Garden, a glamorous Japanese restaurant that opened in 1953 and is still going strong today. Dining in the Tatami (pronounced ta-ta-me) Rooms was a hit in the 1950s. Today people still enjoy being pampered in a warm tropical atmosphere, a place where time is forgotten.

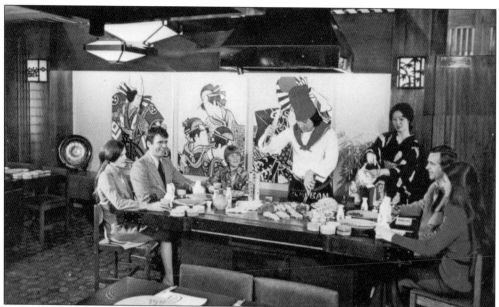

BENIHANA OF TOKYO. Benihana whose motto is, "Your table is our kitchen," is located in the IBM Plaza in downtown Seattle. Written on the backside of this postcard is, "A delightful and entertaining dining experience is Benihana's promise to you. You'll be served the finest in steaks, prepared with skill and showmanship by a chef born and trained in Japan. Shown here is Seattle's new, 40-seat 'Benihana Room.'" (Courtesy of Yoji Kan.)

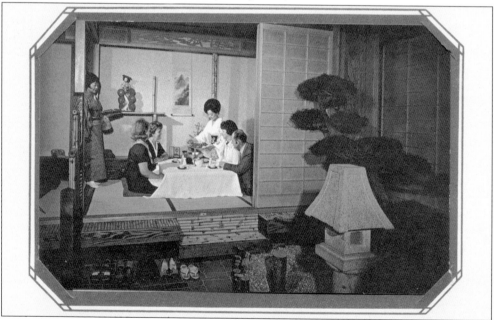

BUSH GARDEN MAILER-STYLE POSTCARD. Roy Seko was the owner and manager of the Japanese restaurant called the Bush Garden in Seattle's international district. On the back of the postcard it stated, "Leisurely dining in a picturesque Japanese atmosphere at the world famous Bush Garden restaurants. . . . Authentic Japanese dishes served by colorfully kimonoed waitresses. . . . The privacy of your own tatami room and your own telephone." (Author's collection.)

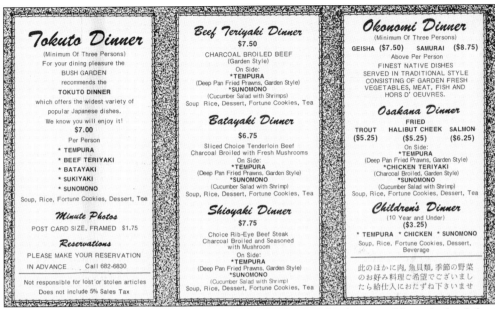

Tokuto Dinner

(Minimum Of Three Persons)
For your dining pleasure the
BUSH GARDEN
recommends the
TOKUTO DINNER
which offers the widest variety of
popular Japanese dishes.
We know you will enjoy it!

$7.00
Per Person

* TEMPURA
* BEEF TERIYAKI
* BATAYAKI
* SUKIYAKI
* SUNOMONO

Soup, Rice, Fortune Cookies, Dessert, Tea

Minute Photos

POST CARD SIZE, FRAMED $1.75

Reservations

PLEASE MAKE YOUR RESERVATION
IN ADVANCE Call 682-6830

Not responsible for lost or stolen articles
Does not include 5% Sales Tax

Beef Teriyaki Dinner

$7.50
CHARCOAL BROILED BEEF
(Garden Style)
On Side:
*TEMPURA
(Deep Pan Fried Prawns, Garden Style)
*SUNOMONO
(Cucumber Salad with Shrimps)
Soup Rice, Dessert, Fortune Cookies, Tea

Batayaki Dinner

$6.75
Sliced Choice Tenderloin Beef
Charcoal Broiled with Fresh Mushrooms
On Side:
*TEMPURA
(Deep Pan Fried Prawns, Garden Style)
*SUNOMONO
(Cucumber Salad with Shrimp)
Soup, Rice, Dessert, Fortune Cookies, Tea

Shioyaki Dinner

$7.75
Choice Rib-Eye Beef Steak
Charcoal Broiled and Seasoned
with Mushroom
On Side:
*TEMPURA
(Deep Pan Fried Prawns, Garden Style)
*SUNOMONO
(Cucumber Salad with Shrimp)
Soup, Rice, Dessert, Fortune Cookies, Tea

Okonomi Dinner

(Minimum Of Three Persons)
GEISHA ($7.50) SAMURAI ($8.75)
Above Per Person
FINEST NATIVE DISHES
SERVED IN TRADITIONAL STYLE
CONSISTING OF GARDEN FRESH
VEGETABLES, MEAT, FISH AND
HORS D' OEUVRES.

Osakana Dinner

FRIED
TROUT HALIBUT CHEEK SALMON
($5.25) ($5.25) ($6.25)
On Side:
*TEMPURA
(Deep Pan Fried Prawns, Garden Style)
*CHICKEN TERIYAKI
(Charcoal Broiled, Garden Style)
*SUNOMONO
(Cucumber Salad with Shrimp)
Soup, Rice, Fortune Cookies, Dessert, Tea

Children's Dinner

(10 Year and Under)
($3.25)
* TEMPURA * CHICKEN * SUNOMONO
Soup, Rice, Fortune Cookies, Dessert,
Beverage

此のほかに肉、魚貝類、季節の野菜
のお好み料理ご希望でございまし
たら給仕人におたずね下さいませ

BUSH GARDEN MENU. When ordering the Sukiyaki dinner, the diner would watch the dish of paper-thin prime rib and crisp vegetables sizzle while sipping on warm sake. Bush Garden was located at 614 Maynard Avenue South. (Author's collection.)

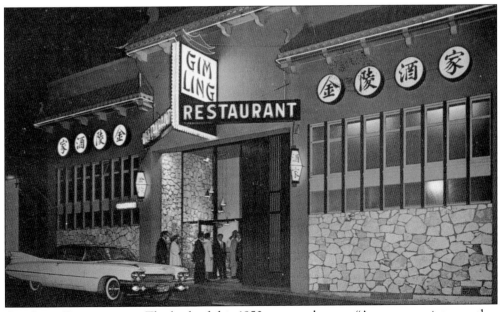

GIM LING RESTAURANT. The back of this 1950s postcard states, "An entrance into another world of truly fine dining. Expertly prepared food that is traditional with our chefs, served in a magnificent atmosphere. An exquisite cocktail lounge to delight all connoisseurs. Dinner reservations appreciated. Main 4-0919 Gim Ling 516 7th Avenue So. Seattle, Washington." (Courtesy of John Cooper.)

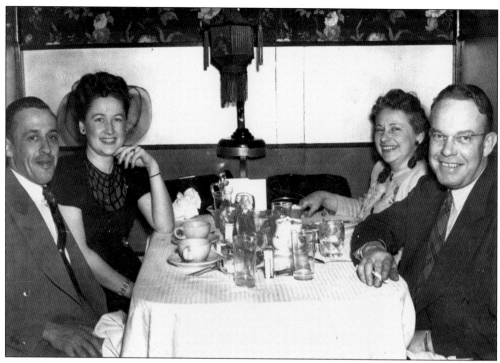

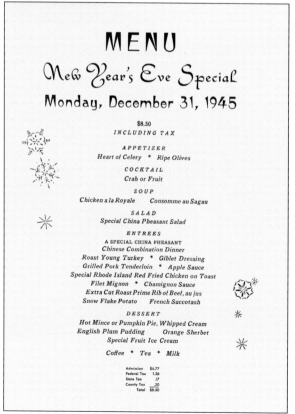

MENU

New Year's Eve Special

Monday, December 31, 1945

$8.50
INCLUDING TAX

APPETIZER
Heart of Celery * Ripe Olives

COCKTAIL
Crab or Fruit

SOUP
Chicken a la Royale Consomme au Sagau

SALAD
Special China Pheasant Salad

ENTREES
A SPECIAL CHINA PHEASANT
Chinese Combination Dinner
Roast Young Turkey * Giblet Dressing
Grilled Pork Tenderloin * Apple Sauce
Special Rhode Island Red Fried Chicken on Toast
Filet Mignon * Chamignon Sauce
Extra Cut Roast Prime Rib of Beef, au jus
Snow Flake Potato French Succotash

DESSERT
Hot Mince or Pumpkin Pie, Whipped Cream
English Plum Pudding Orange Sherbet
Special Fruit Ice Cream

Coffee * Tea * Milk

Admission	$6.77
Federal Tax	1.36
State Tax	.17
County Tax	.20
Total	$8.50

THE CHINA PHEASANT SOUVENIR PHOTOGRAPH. New Year's Eve, on Monday, December 31, 1945, found four friends at the China Pheasant. Surrounding the photograph were the words, "Come back and see us—Bob Harvey," "This and more too-Jo," and "Josie, Never had it so good-says one 'workin' gal to another, Sylvia." (Author's collection.)

CHINA PHEASANT NEW YEAR'S MENU. Shown here is a souvenir menu for New Year's 1945 at the China Pheasant Restaurant, located one mile south of the Seattle city limits on Tacoma Highway at 10315 East Marginal Way. Notice the federal, state, and county taxes. (Author's collection.)

CHINA PHEASANT MENU COVER. On the menu it stated, "A charge of 15¢ per person will be made for ice and/or glass service to patrons who bring liquor in but do not order mixers." The restaurant offered both American and Chinese food. (Author's collection.)

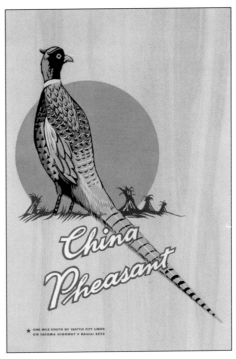

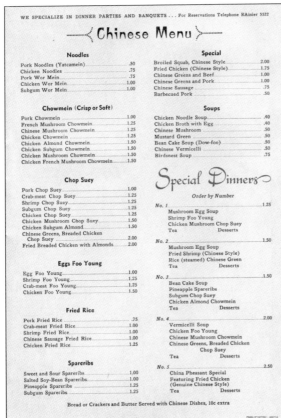

WE SPECIALIZE IN DINNER PARTIES AND BANQUETS . . . For Reservations Telephone RAinier 5522

Chinese Menu

Noodles

Pork Noodles (Yatcamein)	.50
Chicken Noodles	.75
Pork Wor Mein	.75
Chicken Wor Mein	1.00
Subgum Wor Mein	1.00

Chowmein (Crisp or Soft)

Pork Chowmein	1.00
French Mushroom Chowmein	1.25
Chinese Mushroom Chowmein	1.25
Chicken Chowmein	1.25
Chicken Almond Chowmein	1.50
Chicken Subgum Chowmein	1.50
Chicken Mushroom Chowmein	1.50
Chicken French Mushroom Chowmein	1.50

Chop Suey

Pork Chop Suey	1.00
Crab-meat Chop Suey	1.25
Shrimp Chop Suey	1.25
Subgum Chop Suey	1.25
Chicken Chop Suey	1.25
Chicken Mushroom Chop Suey	1.50
Chicken Subgum Almond	1.50
Chinese Greens, Breaded Chicken Chop Suey	2.00
Fried Breaded Chicken with Almonds	2.00

Eggs Foo Young

Egg Foo Young	1.00
Shrimp Foo Young	1.25
Crab-meat Foo Young	1.25
Chicken Foo Young	1.50

Fried Rice

Pork Fried Rice	.75
Crab-meat Fried Rice	1.00
Shrimp Fried Rice	1.00
Chinese Sausage Fried Rice	1.00
Chicken Fried Rice	1.25

Spareribs

Sweet and Sour Spareribs	1.00
Salted Soy-Bean Spareribs	1.00
Pineapple Spareribs	1.25
Subgum Spareribs	1.25

Special

Broiled Squab, Chinese Style	2.00
Fried Chicken (Chinese Style)	1.75
Chinese Greens and Beef	1.00
Chinese Greens and Pork	1.00
Chinese Sausage	.75
Barbecued Pork	.50

Soups

Chicken Noodle Soup	.40
Chicken Broth with Egg	.40
Chinese Mushroom	.50
Mustard Green	.50
Bean Cake Soup (Dow-foo)	.50
Chinese Vermicelli	.50
Birdsnest Soup	.75

Special Dinners

Order by Number

No. 1 1.25
Mushroom Egg Soup
Shrimp Foo Young
Chicken Mushroom Chop Suey
Tea Desserts

No. 2 1.50
Mushroom Egg Soup
Fried Shrimp (Chinese Style)
Rice (steamed) Chinese Green
Tea Desserts

No. 3 1.50
Bean Cake Soup
Pineapple Spareribs
Subgum Chop Suey
Chicken Almond Chowmein
Tea Desserts

No. 4 2.00
Vermicelli Soup
Chicken Foo Young
Chinese Mushroom Chowmein
Chinese Greens, Breaded Chicken
 Chop Suey
Tea Desserts

No. 5 2.50
China Pheasant Special
Featuring Fried Chicken
(Genuine Chinese Style)
Tea Desserts

Bread or Crackers and Butter Served with Chinese Dishes, 10c extra

CHINA PHEASANT CHINESE MENU. As can be seen here, the most expensive item on the menu was No. 5, the China Peasant Special, for $2.50. Every Sunday evening Bob Harvey and his Melody Makers presented Arthur Murray Studios Champagne Hour at the China Pheasant. (Author's collection.)

HONG KONG RESTAURANT. Sam Yee's Hong Kong Restaurant, located at 507 Maynard Avenue South in Chinatown, was the most frequented Chinese restaurant in Seattle's international district. The cooking was traditional Cantonese with such specialties as boned sesame chicken. Cocktails were served in the Sampan Room, where Ruby Chow tended bar. (Courtesy of John Cooper.)

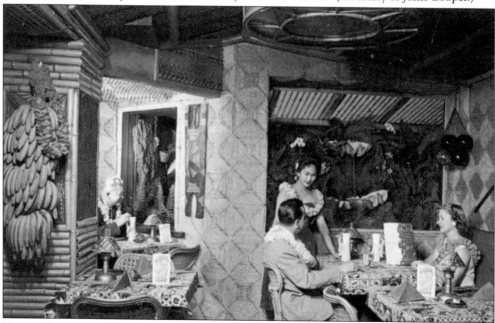

KALUA ROOM. Gwynne Austin developed a Polynesian-style restaurant with a South Seas atmosphere. Diners overlooked an orchid waterfall. This c. 1960 postcard shows the Kalua Room, which was located in the Hotel Windsor. The menu was illustrated with bright red shell and bamboo designs. Two ring-tailed monkeys in an air-conditioned cage entertained diners in another part of the restaurant. (Author's collection.)

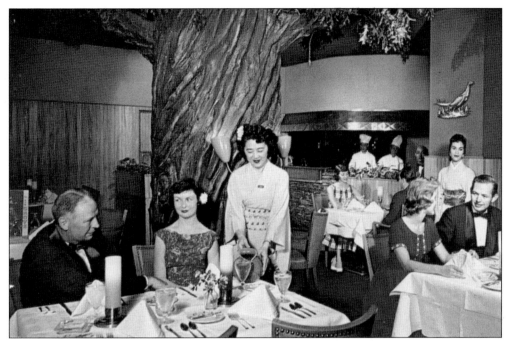

NEW GROVE RESTAURANT. Les Brainard welcomed diners to Seattle's New Grove Restaurant, so named because it was located in a grove of trees. Brainard had his own special seasoning for broiled seafood, steaks, lamb chops, and calf's liver. The restaurant was located at 522 Wall Street in Seattle. (Courtesy of John Cooper.)

TRADER VIC'S OUTRIGGER RESTAURANT. Costumed waiters are serving ostrich meat at Outrigger Restaurant in Seattle in 1960. The Outrigger Restaurant was located in the Ben Franklin Hotel on Fifth Avenue between Virginia and Stewart Streets. (Courtesy of the *Seattle Post-Intelligencer* Collection, MOHAI, No. 1986.5.11384.1.)

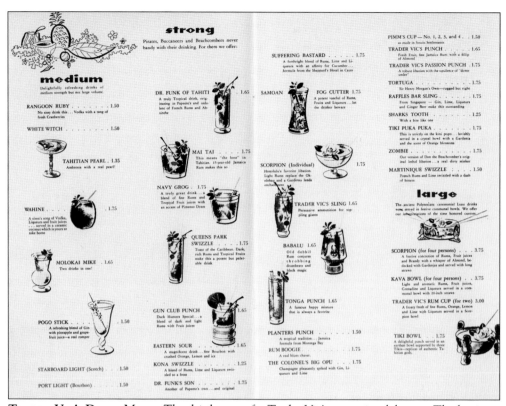

TRADER VIC'S DRINK MENU. The drink menu for Trader Vic's was quite elaborate. The business was well known for its strong mai tais and rum kegs. Dr. Neil Hampson worked evenings as maitre d'. Trader Vic's was visited by celebrities such as Ella Fitzgerald. (Courtesy of Nancy Leson, *Seattle Times*.)

OUTRIGGER RESTAURANT. A waitress is serving customers inside the Outrigger Restaurant in September 1959. The restaurant was created by Trader Vic for Western Hotels, with George Olsen as the manager. There was a Tiki Room with two huge, round Chinese ovens, a Garden Room with greenery and a corrugated tin roof with Oriental newspapers on the ceiling, and a Ship's Cabin copied after the *Yankee Clipper* with wood planks and lanterns. (Courtesy of the *Seattle Post-Intelligencer* Collection, MOHAI, No. 1986.5.11383.1.)

Three

DANCE AND
SUPPER CLUBS

Romantic reminders of days gone by were the clubs just outside the Seattle city limits. During and after Prohibition, these roadhouses were jumping with activity. Seattleites could jump in a car and drive out to have some semi-illicit fun.

On the drive from Seattle north along Victory Way were the Coon Chicken Inn's Club Cotton on the right and then the Jolly Roger on the left. The Coon Chicken Inn opened in 1930, and in 1933, it opened the Club Cotton in its basement for drinking and dancing. According to the *Post-Intelligencer* newspaper, the Jolly Roger opened on July 2, 1934, when Prohibition ended. Prohibition in Washington State lasted from 1916 to 1933.

Tales abound about the Jolly Roger, including its tower being used as a lookout for police raids, its "cribs" (tiny bedrooms) in the basement being used for prostitution, and the tunnels beneath it that could lead one to safety during a police raid. True or not, these tales have been a part of Seattle-area myths for nearly a century.

County tax records prior to 1934 show no building on the Jolly Roger parcel. On December 15, 1933, ten days after the appeal of Prohibition, Gerald Field, a Seattle architect, submitted the plans for the Jolly Roger to Dr. E. B. Fromm, the builder. The King County assessor's record states that it was built in 1930. Perhaps this was confused with the Coon Chicken Inn, which was built in 1930, a theory that Vicki Stiles of the Shoreline Historical Museum brought up in her research. Stiles also questions whether a tunnel existed beneath Victory Way to the Coon Chicken Inn. In her research, Stiles states, "Another story says that the tunnel connected to the Coon Chicken Inn, but the grandson of that establishment's owner assured us that his grandfather would not even acknowledge the presence of the Jolly Roger, so it's unlikely that there was a friendly tunnel between the two places."

True or not, tales continue to swirl around the dance clubs built just outside Seattle city's touch.

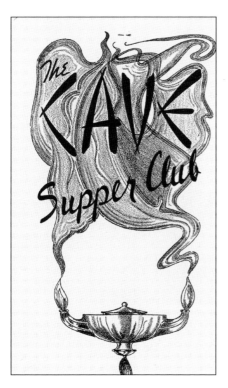

THE CAVE SUPPER CLUB MENU. The supper club would be a part of the nightclub scene in Vancouver, British Columbia, until 1981. According to Chris Wolfe, "This was a major spot in downtown Vancouver and just thousands of acts went through there over the years. The inside of this place as it was actually built to look like the inside of a giant cave! . . . Great atmosphere, and a real theater nightclub." (Author's collection.)

CAVE SUPPER CLUB MENU (INSIDE). The Cave Supper Club opened on Hornby Street. Richard Main said, "My uncle and aunt, Dave and Lillian Davies, owned the Cave club in the 1950s. I remember them complaining about how difficult and egotistical many of the big-name stars were, in particular Diana Ross." (Author's collection.)

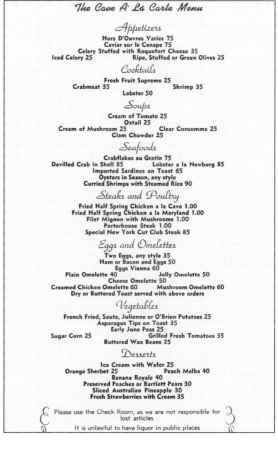

The Cave A' La Carte Menu

Appetizers

Hors D'Ouvres Varies 75
Caviar sur le Canape 75
Celery Stuffed with Roquefort Cheese 35
Iced Celery 25 Ripe, Stuffed or Green Olives 25

Cocktails

Fresh Fruit Supreme 25
Crabmeat 35 Shrimp 35
Lobster 50

Soups

Cream of Tomato 25
Oxtail 25
Cream of Mushroom 25 Clear Consomme 25
Clam Chowder 25

Seafoods

Crabflakes au Gratin 75
Devilled Crab in Shell 85 Lobster a la Newburg 85
Imported Sardines on Toast 65
Oysters in Season, any style
Curried Shrimps with Steamed Rice 90

Steaks and Poultry

Fried Half Spring Chicken a la Cave 1.00
Fried Half Spring Chicken a la Maryland 1.00
Filet Mignon with Mushrooms 1.00
Porterhouse Steak 1.00
Special New York Cut Club Steak 85

Eggs and Omelettes

Two Eggs, any style 35
Ham or Bacon and Eggs 50
Eggs Vienna 60
Plain Omelette 40 Jelly Omelette 50
Cheese Omelette 50
Creamed Chicken Omelette 60 Mushroom Omelette 60
Dry or Buttered Toast served with above orders

Vegetables

French Fried, Saute, Julienne or O'Brien Potatoes 25
Asparagus Tips on Toast 35
Early June Peas 25
Sugar Corn 25 Grilled Fresh Tomatoes 35
Buttered Wax Beans 25

Desserts

Ice Cream with Wafer 25
Orange Sherbet 25 Peach Melba 40
Banana Royale 40
Preserved Peaches or Bartlett Pears 30
Sliced Australian Pineapple 30
Fresh Strawberries with Cream 35

Please use the Check Room, as we are not responsible for lost articles
It is unlawful to have liquor in public places

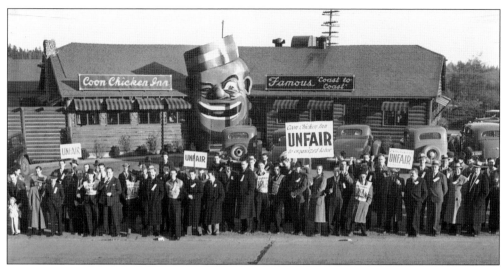

COON CHICKEN INN. The Coon Chicken Inn was founded by Maxon Lester Graham and his wife, Adelaide née Burt, in 1925 in Salt Lake City, Utah. In 1929, they opened their Seattle restaurant at 8500 Bothell Way across from the Jolly Roger restaurant. The signs read, "Coon Chicken Inn, unfair to organized labor," in the above photograph taken during a labor dispute in the 1950s. (Courtesy of the *Seattle Post-Intelligencer* Collection, MOHAI, No. Pl-24093.)

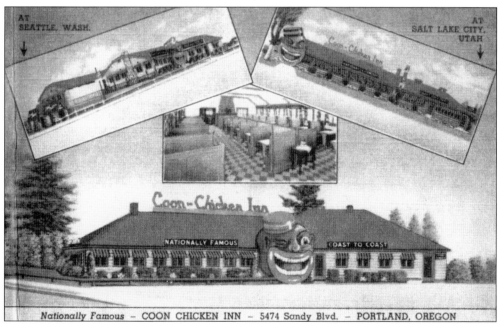

COON CHICKEN INN POSTCARD. This reproduction postcard shows the three locations of the Coon Chicken Inn. The Salt Lake City, Utah, location started with a small building that contained three stools, an icebox, and a small counter costing $50. The second location was in Seattle, and in 1930 the third location was added in Portland, Oregon. (Author's collection.)

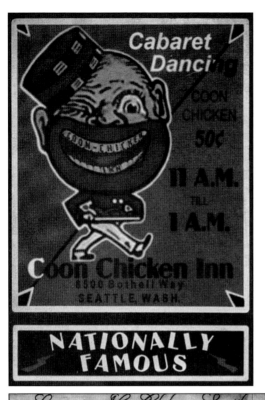

COON CHICKEN INN MENU. Maxon Lester Graham wanted to attract children to his restaurants, who would in turn bring their parents. He decided on the gimmick of adding the famous head logo to the entrances of the inns. The logo was a huge, winking, grinning face of a black man wearing a porter's cap. Outrageous red lips framed teeth with the words, "Coon Chicken Inn." (Author's collection.)

COON CHICKEN INN MENU (INSIDE). Prohibition in Washington State lasted until 1933 (notice that no alcohol is on this menu). The Grahams left the restaurant business in the 1950s and leased out the buildings to other restaurateurs. The Seattle site is now Yings Drive-In; the Portland, Oregon, location is currently Clyde's Prime Rib Restaurant; and the Salt Lake City, Utah, location is the Chuck-A-Rama buffet. (Author's collection.)

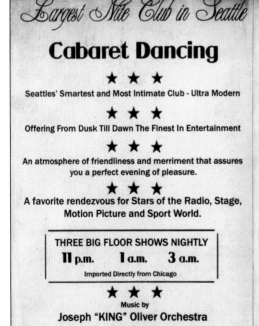

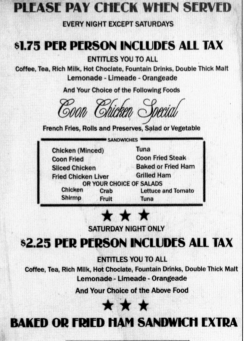

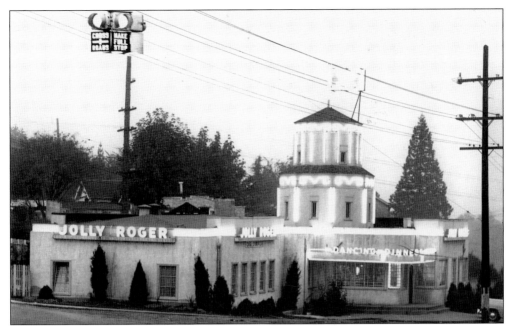

JOLLY ROGER ROADHOUSE. This 1935 photograph of the Jolly Roger showed a pink stucco building with a two-tiered tower located at 8721 Lake City Way. Vicki Stiles of the Shoreline Historical Society could find no evidence that the Jolly Roger had been a speakeasy, nor had the unique tower been used to warn patrons of police raids so they could slip away through a tunnel. Stiles did concede, however, that there might have been illegal gambling on the site, but that any tunnel's existence has yet to be proven. (Courtesy of the Shoreline Historical Museum, No. 1982.)

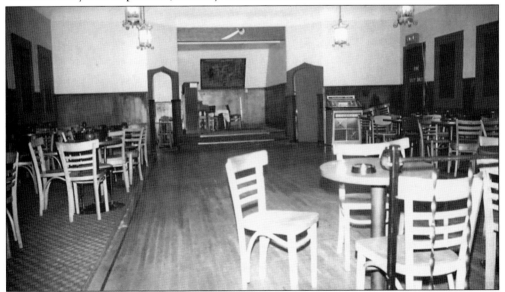

JOLLY ROGER ROADHOUSE BAR. The Jolly Roger was a popular dance hall and restaurant. On October 18, 1989, the Jolly Roger was suspiciously destroyed by fire. Denchai Sae-Eal owned the building and was in a legal battle with Yeong Huei-Wen, the previous owner. Wen was in the building removing his possessions when the fire began in the cluttered basement. (Courtesy of the Shoreline Historical Museum, No. 2028.)

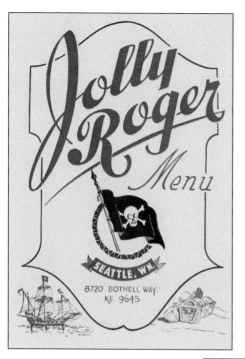

JOLLY ROGER MENU. This photograph shows the front cover of the Jolly Roger menu. The menu had a buccaneer theme with a pirate shooting two muskets over treasure on the background. A coffee cost 10¢ and a pint of beer cost 30¢, while a quart of beer sold for 80¢. A pint of Eastern Beer was 35¢ and a quart was 90¢. A minimum food charge of 50¢ was applied to each person. (Author's collection.)

JOLLY ROGER MENU (INSIDE). The weekday hours were from 4:00 p.m. to 3:00 a.m., and on Fridays and Saturdays, it was open all night. Interestingly, the menu stated that, "Patrons Supplying Their Mixer Will Be Charged Our Menu Prices." Coffee would only be served with food. On the menu were special full-course dinners that ranged in price from $2 to $2.50 and included chicken livers and giblets as well as sirloin steak. (Author's collection.)

Coffee Served with Food Only

OPEN from 4 P.M. to 3 A.M. FRIDAY and SATURDAY ALL NIGHT

SALADS

Lettuce and Tomato60; ½ .35	Head Lettuce, French Dressing60
Fruit Salad..............................1.00	One-half35
Crab....................................1.25	Chicken1.25
Combination1.00	Shrimp1.25
Cocktails—Shrimp, Crab or Fruit60
Relish—Olives or Sweet Pickles50

☆ ☆

Served 12 A.M. till 2 A.M.

SPECIAL FULL COURSE DINNER

Cocktail: Shrimp or Fruit

Relish Sweet Pickles Olives

Soup: Cream of Tomato

Salads: Fruit or Head Lettuce with French Dressing

CHICKEN PIE with French Fries and Toast 75c	Choice	CHICKEN SMACKS with French Fries Hot Roll and Honey $1.00
	Sirloin - Dinner Steak - 2.50	
	Fried Spring Chicken Unjointed - 2.25	
	Fried Chicken Giblets - 2.25	
	Fried Chicken Livers, Bacon - 2.25	

Roast Sirloin of Beef, or Baked Ham - 2.00
Roast Tom Turkey, Dressing, Cranberry Sauce - 2.00
Fried Willa Point Oysters - 2.00
Breaded Veal Cutlets with Tomato Sauce - 2.00

Potatoes and Vegetable
Ice Cream or Sherbet Coffee, Tea or Milk

A LA CARTE — READY TO SERVE

HOT SANDWICHES		ROASTS	
Hot Beef Sandwich	.90	Baked Ham with Brown Sauce..1.25	
Hot Steak Sandwich	1.00	Roast Tom Turkey, Dressing 1.25	
Baked Ham Sandwich	.90	Roast Sirloin of Beef 1.25	
Hot Turkey Sandwich	.90		

Patrons Supplying Their Mixer Will Be Charged Our Menu Prices

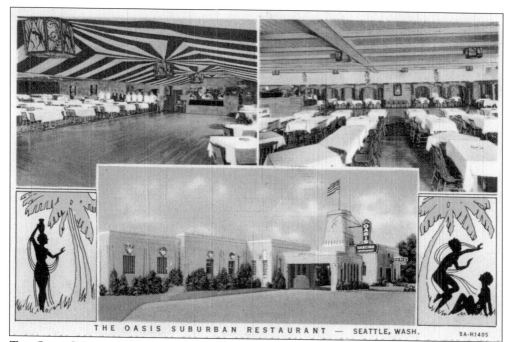

THE OASIS SUBURBAN RESTAURANT — SEATTLE, WASH.

THE OASIS SUBURBAN RESTAURANT. This 1930s or 1940s color linen postcard shows the Oasis Suburban Restaurant, which was located at Aurora Avenue and 140th Street. Dancing and entertainment were from 9:00 p.m. until 2:30 a.m. daily. (Author's collection.)

SEATTLE'S THEATRE CAFE

Located Eight Miles North of Seattle's City Limits

THE RANCH POSTCARD. The Ranch presented a floor show nightly, except Sundays. There was dancing from 9:00 p.m. until 2:30 a.m. with no cover charge. The Ranch restaurant operated during Prohibition and was located outside the Seattle city limits. (Courtesy of Mary Patterson.)

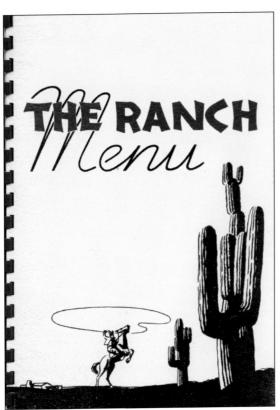

THE RANCH MENU. The Ranch's menu featured a Western motif, with a cowboy on a horse with a rope and cacti. (Author's collection.)

THE RANCH MENU (INSIDE). On the Ranch's menu it stated, "Persons bringing liquor in will be charged 15¢ per person for ice and/or glass service if you do not order mixers. Two glasses served with each bottle of mixer. Extra glasses 15¢ each." (Author's collection.)

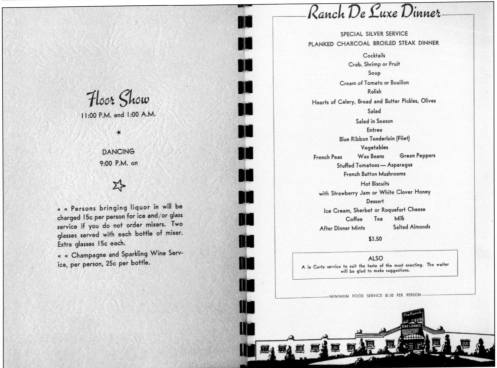

Floor Show

11:00 P.M. and 1:00 A.M.

★

DANCING

9:00 P.M. on

☆

« « Persons bringing liquor in will be charged 15c per person for ice and/or glass service if you do not order mixers. Two glasses served with each bottle of mixer. Extra glasses 15c each.

« « Champagne and Sparkling Wine Service, per person, 25c per bottle.

Ranch De Luxe Dinner

SPECIAL SILVER SERVICE
PLANKED CHARCOAL BROILED STEAK DINNER

Cocktails

Crab, Shrimp or Fruit

Soup

Cream of Tomato or Bouillon

Relish

Hearts of Celery, Bread and Butter Pickles, Olives

Salad

Salad in Season

Entree

Blue Ribbon Tenderloin (Filet)

Vegetables

French Peas Wax Beans Green Peppers

Stuffed Tomatoes — Asparagus

French Button Mushrooms

Hot Biscuits

with Strawberry Jam or White Clover Honey

Dessert

Ice Cream, Sherbet or Roquefort Cheese

Coffee Tea Milk

After Dinner Mints Salted Almonds

$3.50

ALSO

A la Carte service to suit the taste of the most exacting. The waiter will be glad to make suggestions.

—— MINIMUM FOOD SERVICE $1.50 PER PERSON ——

Four

NOSTALGIC DRIVE-INS

Many people miss the good old days of cheap, fast, tasty hamburgers with hot French fries. Some nostalgic drive-ins have come and gone while others have stood the test of time. Fast food is the term given to many items that can be prepared and served quickly, and was recognized in a dictionary by Merriam-Webster in 1951. In the United States, a typical fast food meal is a hamburger, fries, and a drink. In the early 1950s, travel by automobile was commonplace, and people wanted places that they could order a quick, inexpensive meal on the go. Several drive-ins fulfilled this need. Setting the standard for the finest fast food in Seattle was exactly the objective of the three associates who started Dick's Drive-In. "Our goal," said Dick Spady, who is the only one of the three original partners who still works in the business, "was simply to serve fresh, high quality food at low prices with instant service."

Dick's Drive-In originally opened in 1954 and grew to five different locations. Its staples were hamburgers for 19¢; fresh, hand-cut potato fries for 11¢; and a hand-dipped milk shake for 21¢. Popular menu items included the "Dick's Deluxe," a hamburger with lettuce, mayonnaise, and chopped pickles; and the "Dick's Special," a hamburger with cheese that debuted in 1971. Dick's Drive-In has tip jars for local charities and offers scholarships for its student employees. The Wallingford location opened in 1954, the Capital Hill location in 1955, the Crown Hill location in 1960, the Lake City location in 1963, and the Queen Anne location in 1974. Dick's Drive-Ins are still open and are still offering scholarships.

Dag's Drive-In also served its well-known hamburgers, such as the "Dagilac" and the "Beefy Boy." The chain was open from 1955 to 1993 by founders Ed and Boe Messett. Eight other Dag's Drive-Ins opened through the years.

Drive up, drive in, and visit one today.

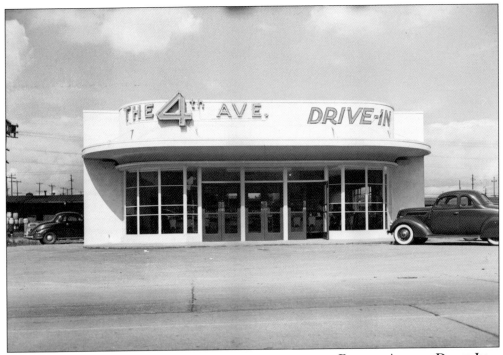

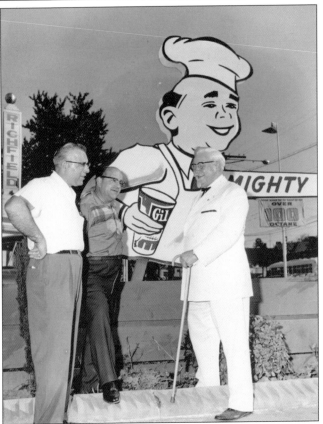

FOURTH AVENUE DRIVE-IN. This 1940 photograph shows the Fourth Avenue Drive-In. One of the early pioneers, the restaurant switched its appliances from gas to all electric. (Courtesy of the Seattle Municipal Archives, No. 18872.)

COLONEL SANDERS AT GIL'S DRIVE-IN. On June 30, 1959, this photograph was taken of an unidentified man, Gil Centiolli, and Harland Sanders, also known as Colonel Sanders, at Gil's Drive-In, which was located at 1001 Pine Street. Soon after this photograph was taken at least one of the Gil's Drive-Ins became a Kentucky Fried Chicken. (Courtesy of the Robert H. Miller Collection, MOHAI, No. 2864.)

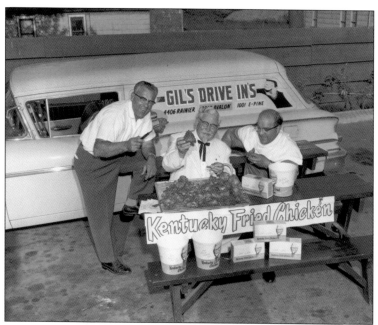

Colonel Sanders at Gil's Drive-In. Colonel Sanders is shown eating fried chicken at Gil's Drive-In in Seattle on June 30, 1959. During the 1950s, Gil Centiolli owned three fast food drive-ins known as Gil's Hamburgers. (Courtesy of the Robert H. Miller Collection, MOHAI, No. 2002.46.18.)

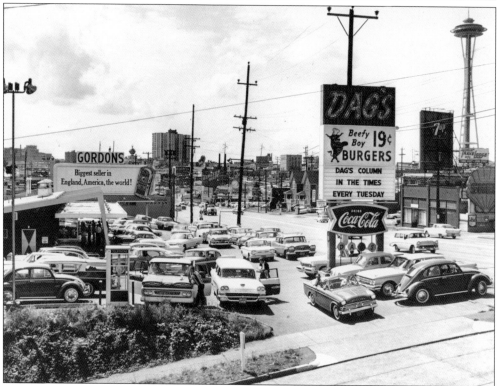

Dag's Drive-In. The world headquarters of Dag's Drive-In was located on Aurora Avenue. The founders, Ed and Boe Messett, named the drive-in after their father. Bob Ward, their press agent, came up with the slogans, including "This is Dag's . . . Canlis is ten bucks north," "Home of the Dagilac," and "This is Dag's." Dag's is now a parking lot on Aurora Avenue. (Courtesy of MOHAI, No. 2004.57.)

DICK'S DRIVE-IN RESTAURANTS. The first Dick's Drive-In opened in Seattle's Wallingford neighborhood on Northeast Forty-fifth Street in 1954. The founders were Dr. B. O. A. Thomas, H. Warren Ghormley, and Dick Spady. This 1993 photograph shows the Almost Live performers and writers posing for a promotional shot at Dick's Drive-In. Pictured from left to right are Bill Stainton, Tracy Conway, Steve Wilson, Nancy Guppy, Bob Nelson, John Keister, and Ed Wyatt. (Courtesy of Dick's Drive-In.)

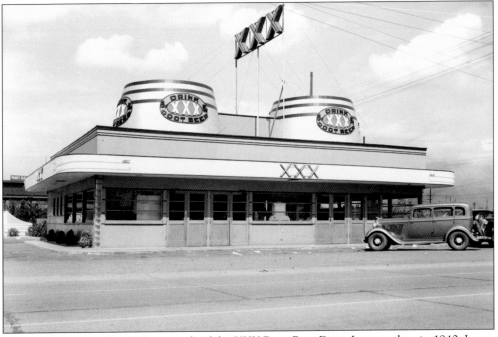

ROOT BEER DRIVE-IN. A photograph of the XXX Root Beer Drive-In was taken in 1940. It was converted to be an all-electric restaurant. Currently, there is still a Triple X drive-in in Issaquah, Washington. (Courtesy of the Seattle Municipal Archives, No. 18871.)

Five

FREDERICK AND NELSON RESTAURANTS

Frederick and Nelson Restaurants were icons in Seattle's history. The store was originally located at Fifth Avenue and Pine Street. It had several restaurants, including the Tea Room, the Men's Grill, Paul Bunyan, and a continental buffet. "Frederick's Folly," as some called it, opened on September 3, 1918. The store was an instant success. Frederick and Nelson was founded by Nels B. Nelson (1854–1907) and Donald E. Frederick (1860–1937). The last page of the Frederick and Nelson Tea Room menu describes the amenities:

Dining at Frederick and Nelson:

The Tea Room, on the eighth floor, specializes in fine food and excellent service in a pleasant, luxurious atmosphere. Here, Seattle's fashionable women meet daily to converse at luncheon or tea in leisurely comfort.

Every Wednesday, the newest trends in women's apparel are modeled informally during luncheon . . . a popular event for both local women and their out-of-town guests.

Luncheon and teatime service is available daily except Sundays, and dinner is served on Mondays and other evenings when the store remains open.

The Continental Buffet adjoins the Tea Room, offers a quick selection of delicious foods, salads, sandwiches, and deserts served in a buffet style. Dinner is available in the Buffet on those nights when the store remains open. Informal modeling of current fashions occurs every Wednesday.

The Men's Grill, also on the eighth floor, is reserved for *men only* from Monday through Friday. The oak-paneled décor lends a clubroom atmosphere to the special menu prepared to a man's taste. The Grill is opened for family groups on Saturdays. Informal modeling of current women's fashions each Wednesday.

Private Party Rooms adjoining the Men's Grill and Continental Buffet are available by advance reservation to groups numbering from 15 to 75 persons.

The Paul Bunyan Kitchen is conveniently located on the Budget Floor (downstairs) where busy shoppers can enjoy fast over-the-counter service featuring hearty sandwiches, salads, pastries, and fountain specialties. Try the famous Frederick and Nelson beef or chicken pies, which are also available to take home.

The Rhododendron Room, in our Bellevue store, offers either counter or buffet service of a select assortment of Frederick and Nelson's finest delicacies.

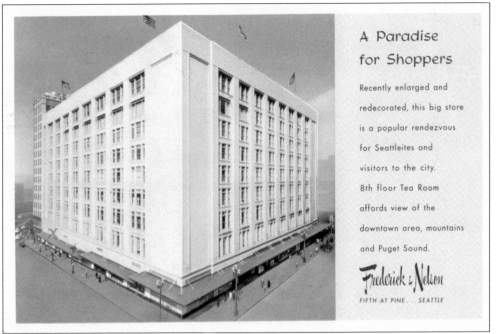

FREDERICK AND NELSON DEPARTMENT STORE. This 1953 postcard text reads, "A paradise for shoppers. Recently enlarged and redecorated, this big store is a popular rendezvous for Seattleites and visitors to the city. Eighth floor Tea Room affords view of the downtown area, mountains, and Puget Sound." (Authors collection.)

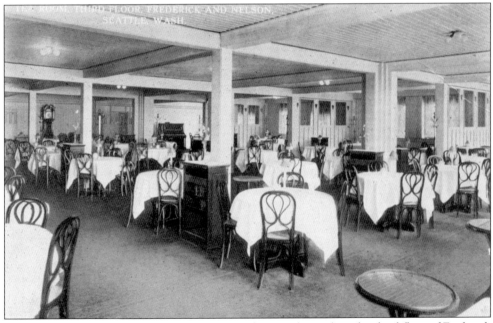

TEA ROOM POSTCARD. The Tea Room in its early years, located on the third floor of Frederick and Nelson in Seattle, is shown on this postcard, dated 1913. (Courtesy of John Cooper.)

FREDERICK AND NELSON TEA ROOM MENU. The menu cover featured here was cream colored with two rhododendron blossoms. The rhododendron is the Washington State flower. The elaborate menu had five pages and was tied together with a gold strand of braiding. (Courtesy of Nancy Leson, *Seattle Times*.)

the Frederick & Nelson tea room

tea time specialties

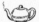

Enjoy a piping hot pot of our *Famous Teas

Our Creamed Chicken over Patty Shell with Buttered Vegetable and
Molded Fruit Salad 1.90

Tea Room Plate—Assorted Ribbon Sandwiches with Fresh Fruit
Sections and French Pastry 1.40

Chicken and Crab Salads on Tomato Slices over Toast Rounds,
Olympic Berry Sherbet 1.45

Fresh Fruit Salad with Cream Cheese Swirl, Toasted Nut Bread
and Marmalade 1.55

"Ye Olde Toasted English" Muffin or Crumpet—with Lime or
Orange Marmalade55

Cinnamon Toast .45

Nut Bread Toast and Currant Jelly45

*Choose from: Bigelow's "Constant Comment," Twinings English Breakfast
Tea, Twinings Earl Grey Tea, Twinings Darjeeling Tea, Twinings
Orange Pekoe or Frederick & Nelson Tea Room blend50

*For other menu selections, please see our Frederick & Nelson
Desserts, Salads, Sandwiches and Fountain Suggestions.*

TEA ROOM MENU, PAGE ONE. Tea time specialties were listed on the first page of the Frederick and Nelson Tea Room menu. Julie Albright (editor), who once lived in Seattle and often ate here with her mother, said she could probably recite the entire menu. (Courtesy of Nancy Leson, *Seattle Times*.)

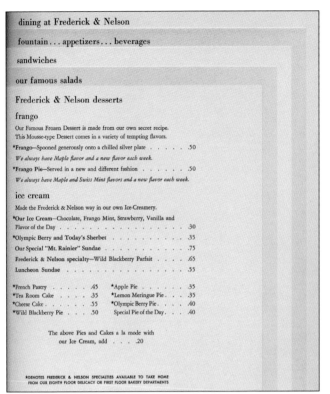

dining at Frederick & Nelson

fountain... appetizers... beverages

sandwiches

our famous salads

Frederick & Nelson desserts

frango

Our Famous Frozen Dessert is made from our own secret recipe.
This Mousse-type Dessert comes in a variety of tempting flavors.

*Frango—Spooned generously onto a chilled silver plate50

We always have Maple flavor and a new flavor each week.

*Frango Pie—Served in a new and different fashion50

We always have Maple and Swiss Mint flavors and a new flavor each week.

ice cream

Made the Frederick & Nelson way in our own Ice-Creamery.

*Our Ice Cream—Chocolate, Frango Mint, Strawberry, Vanilla and
Flavor of the Day30

*Olympic Berry and Today's Sherbet35

Our Special "Mt. Rainier" Sundae75

Frederick & Nelson specialty—Wild Blackberry Parfait65

Luncheon Sundae55

*French Pastry	.45	*Apple Pie	.35
*Tea Room Cake	.35	*Lemon Meringue Pie	.35
*Cheese Cake	.55	*Olympic Berry Pie	.40
*Wild Blackberry Pie	.50	Special Pie of the Day	.40

The above Pies and Cakes a la mode with
our Ice Cream, add20

*DENOTES FREDERICK & NELSON SPECIALTIES AVAILABLE TO TAKE HOME
FROM OUR EIGHTH FLOOR DELICACY OR FIRST FLOOR BAKERY DEPARTMENTS

TEA ROOM MENU, PAGE TWO. Frederick and Nelson desserts were on page two and included its Frango pie, Frango mint ice cream, Frango frozen desert, and Olympic berry pie. The store bought the entire crop of Olympic berries. Frango candies only left the kitchens when Frederick and Nelson became part of Marshall Field and Company. (Courtesy of Nancy Leson, *Seattle Times*.)

TEA ROOM MENU, PAGE THREE. On the menu on page three were the famous salads. The finest quality lettuce, avocados, tomatoes (regularly peeled), and fruit were purchased for the restaurant. (Courtesy of Nancy Leson, *Seattle Times*.)

dining at Frederick & Nelson

fountain... appetizers... beverages

sandwiches

our famous salads

Many of these salads were created in our own Frederick & Nelson Kitchens and have
been the favorites of our guests for over twenty-five years.

†Diet Delight—Ocean Fresh Dungeness Crab, surrounded by sliced Tomatoes,
sections of Grapefruit, and a bed of crisp Romaine 2.15

Assorted Salad Plate—A tempting arrangement of Chicken Salad, Vegetables,
Fruit Salad, Cottage Cheese, Deviled Eggs and Tomato Juice center 2.25

Crab Ravessant—A long-time Frederick & Nelson Favorite created in our
Kitchens and made with Dungeness Crab Legs, Crab Salad, Avocado,
Grapefruit sections and Tomato wedges 2.60

Chicken Salad—Tender diced Chicken, chopped Egg and Celery blended with
Frederick & Nelson Fresh Mayonnaise 2.25

†Fresh Fruit Salad—A choice array of Fresh Fruit with Avocado, Banana,
Grapefruit sections, Orange sections, Pineapple and seasonal fruits. 2.35

Dungeness Crab Salad—Ocean Fresh Dungeness Crab, chopped Egg and Celery
blended with Frederick & Nelson Fresh Mayonnaise 2.25

†Cottage Cheese and Fruit—Made of Freestone Peach half, Bartlett Pear
half, jumbo Pineapple slice, over Fresh Cottage Cheese, garnished 1.80

Alaska Shrimp Salad—Fresh Alaska Shrimp, chopped Egg and Celery
blended with Frederick & Nelson Fresh Mayonnaise 2.15

Dungeness Crab Louie—A Pacific Northwest Favorite made with Fresh
Dungeness Crab Meat, Tomato wedges, Green Pepper and Egg wedges . . . 2.60

Choice of Diet, Fruit, French, Pineapple, Mayonnaise or Thousand Island Dressing

CHOICE OF OUR BAKED MUFFIN OR ROLL

†Served with low calorie diet dressing and rye crisp

TEA ROOM MENU, PAGE FOUR. Sandwiches were on page four of the menu. The bread was handmade from unbleached flour and was baked fresh daily. (Courtesy of Nancy Leson, *Seattle Times*.)

dining at Frederick & Nelson

fountain... appetizers... beverages

sandwiches

All Sandwiches generously filled, appropriately garnished and served on White, Whole Wheat, Rye or Tomato Cheese Bread, fresh daily from our own Bakery.

Broiled Frederick & Nelson Sandwich—Ham, Crisp Bacon, and New York Cheddar Cheese	1.65
Cold Prime Rib of Beef	1.55
Corned Beef	1.40
Egg Salad	1.10
Tuna Salad	1.10
Frederick & Nelson Club Sandwich	2.10
Sliced Chicken—White and Dark Meat	1.55
All White Meat	1.65
Open Face Chicken Salad on Tomato Slice	1.50
Baked Premium Ham	1.25
Spiced Tongue	1.25
New York Cheddar Cheese	1.10
Broiled Dungeness Crab with New York Cheddar Cheese and Bacon strips	1.80

Marshall Field's Famous Special Sandwich—Sliced Breast of Chicken, domestic Swiss Cheese, Lettuce, Tomato, and Hard Cooked Egg on Rye Bread, Thousand Island Dressing, Crisp Bacon and a Ripe Olive 1.95

dining at Frederick & Nelson

fountain... appetizers... beverages

Ice Cream Soda—Chocolate, Frango Mint, Strawberry or Vanilla
Made with our own Ice Cream50

Milk Shakes or Malts—Chocolate, Frango Mint, Strawberry or Vanilla
Made with our own Ice Cream50

Sundaes—Chocolate, Frango Mint, Hot Caramel, Hot Fudge or Strawberry
Made with our own rich Ice Cream and Topping, garnished with Whipped
Cream, and Walnut Halves, served with extra Topping and Cookies75

Lime, Lemon or Orange Ade .35

appetizers

Chicken Broth with Rice	.25
Tomato Juice Supreme	.35
Fresh Fruit Cup Supreme	.75
Dungeness Crab Cocktail, Supreme	.95
Alaska Shrimp Cocktail, Supreme	.95

beverages

Milk	.20	Iced Tea or Coffee	.25
Buttermilk or Skim Milk	.20	*Frederick & Nelson Tea	.25
Cocoa—pot	.25	Postum	.25
Coca Cola	.20	Sanka	.25
*Frederick & Nelson Blend Coffee	.25		

*DENOTES FREDERICK & NELSON SPECIALTIES AVAILABLE TO TAKE HOME
FROM OUR EIGHTH FLOOR DELICACY OR FIRST FLOOR BAKERY DEPARTMENTS

TEA ROOM MENU, PAGE FIVE. On page five were fountain drinks, appetizers, and other beverages. The famous Frango mint milk shake cost only 50¢. (Courtesy of Nancy Leson, *Seattle Times*.)

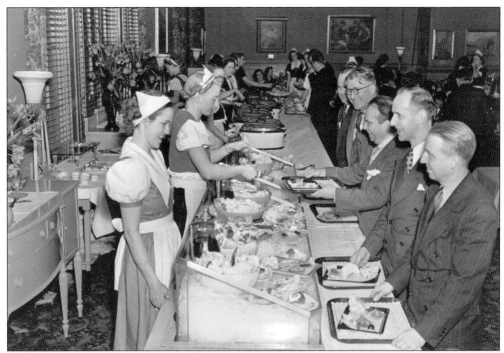

CONTINENTAL BUFFETT AT FREDERICK AND NELSON. Waitresses serve fresh food to businessmen at the Continental Buffet in 1939. (Courtesy of the *Seattle Post-Intelligencer* Collection, MOHAI, PI21069.)

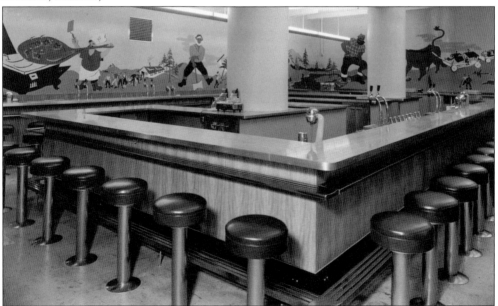

PAUL BUNYAN KITCHEN, 1948. Located in the basement of the Frederick and Nelson department store was a café that served salads, sandwiches, and soda fountain drinks. The Paul Bunyan was a favorite stop for families when they shopped in downtown Seattle. The murals illustrate the legend of the logging hero Paul Bunyan. (Courtesy of PEMCO Webster and Stevens Collection, MOHAI, 1983.10.16867.2.)

Six

CLARKS ALL OVER TOWN

Walter Frederick Clark built an enormously successful empire of 53 restaurants over a period of 55 years. An excerpt from the back of Clark's Totem Café menu tells the story of the famous Clark's restaurants:

Clark's Restaurants have been a part of the Seattle story since 1930. From a very humble beginning, we strive year by year to build friendly restaurants that will fulfill a need in the community.

We have unfounded faith in the future of Seattle. We have tried to keep pace with Seattle's growth by carefully locating our restaurants where we might best serve an expanding community.

Clark's Restaurants are completely local enterprises. Every dollar spent in Clark's Restaurants is distributed in the community,—in wages, utilities, rentals, foods, and supplies.

We have progressively improved our restaurants with the finest equipment to enable our staff to serve wholesome well prepared food.

It is the sincere desire of the management to render a constantly better service to the many thousands of customers and friends whose loyal patronage has made this progress over the past 21 years possible.

Clark's Restaurants include . . . Clark's Restaurant Enterprises, Inc.; Clark's Salad Bowl; Clark's Fifth Avenue; Clark's Round the Clock; Clark's Top Notch; Clark's Catering Companies; Clark's Bakery. Affiliated Enterprises . . . Clark's Twin T-P's, Inc.; Clark's Food Service; Clark's Seventh and Bell, Inc.; Clark's Northgate, Inc.; Capital Caféteria; and Totem Café and Recreation, Inc.

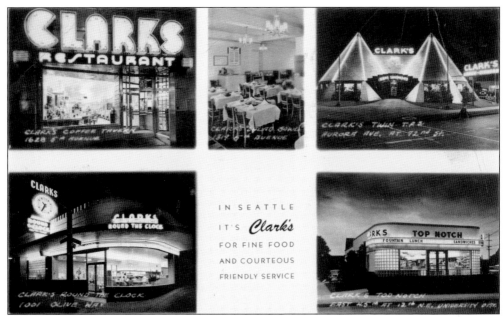

CLARK'S RESTAURANTS POSTCARD. Clark's in Seattle was well known for fine food and courteous, friendly service, as this postcard states. This postcard features Clark's Coffee Tavern, Clark's Salad Bowl, Clark's Twin T-P's, Clark's Round the Clock, and Clark's Top Notch. (Courtesy of Yoji Kan.)

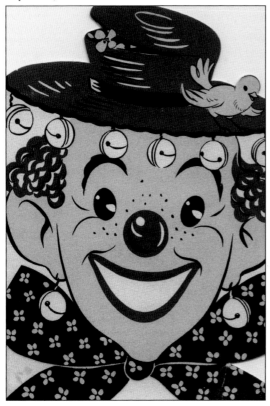

CLARK'S CHILDREN'S MENU. This clown-faced children's menu was used in several of Clark's restaurants. (Author's collection.)

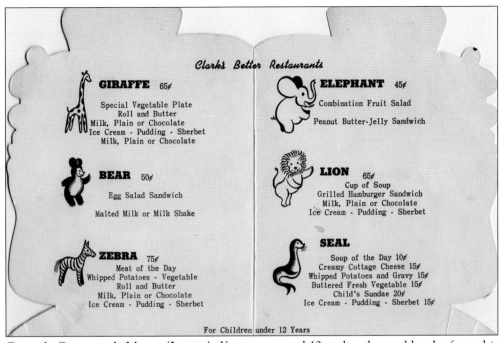

Clark's Better Restaurants

GIRAFFE 65¢
Special Vegetable Plate
Roll and Butter
Milk, Plain or Chocolate
Ice Cream - Pudding - Sherbet
Milk, Plain or Chocolate

ELEPHANT 45¢
Combination Fruit Salad
Peanut Butter-Jelly Sandwich

BEAR 50¢
Egg Salad Sandwich

Malted Milk or Milk Shake

LION 65¢
Cup of Soup
Grilled Hamburger Sandwich
Milk, Plain or Chocolate
Ice Cream - Pudding - Sherbet

ZEBRA 75¢
Meat of the Day
Whipped Potatoes - Vegetable
Roll and Butter
Milk, Plain or Chocolate
Ice Cream - Pudding - Sherbet

SEAL
Soup of the Day 10¢
Creamy Cottage Cheese 15¢
Whipped Potatoes and Gravy 15¢
Buttered Fresh Vegetable 15¢
Child's Sundae 20¢
Ice Cream - Pudding - Sherbet 15¢

For Children under 12 Years

CLARK'S CHILDREN'S MENU (INSIDE). Youngsters aged 12 and under could order from this clown-faced menu. Sparklers also adorned children's sundaes as waitresses carried them through the restaurant. Walter Clark wanted his young patrons to feel special. (Author's collection.)

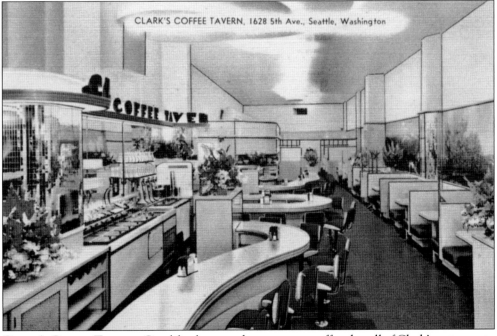

CLARK'S COFFEE TAVERN. Good food at a moderate cost was offered at all of Clark's restaurants. This postcard shows the remodeled coffee tavern in 1942. The menu featured sandwiches, salads, and special dietary items that appealed to medical and dental professionals as well as to shoppers from Frederick and Nelson. (Author's collection.)

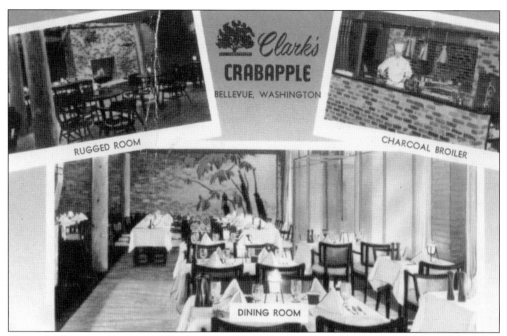

CLARK'S CRABAPPLE. Across the famous floating bridge from Seattle under a huge Madonna tree in Bellevue Square was Clark's Crabapple. In the dining room there was a charcoal broiler combined with the fireplace, and the business served "Chicken Every Sunday." (Courtesy of Mary Patterson.)

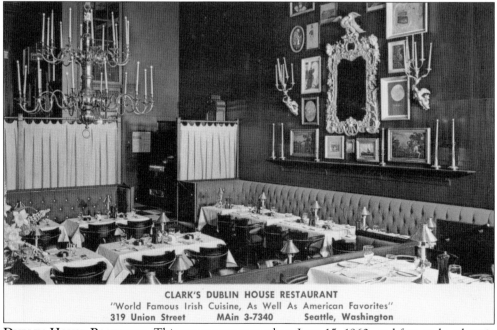

DUBLIN HOUSE POSTCARD. This restaurant opened on June 15, 1960, and featured authentic Irish specialties as well as American food. Dublin House was located at 319 Union Street and had walls paneled in dark mahogany featuring antique art from Ireland amid Kelly green–tufted upholstery. (Author's collection.)

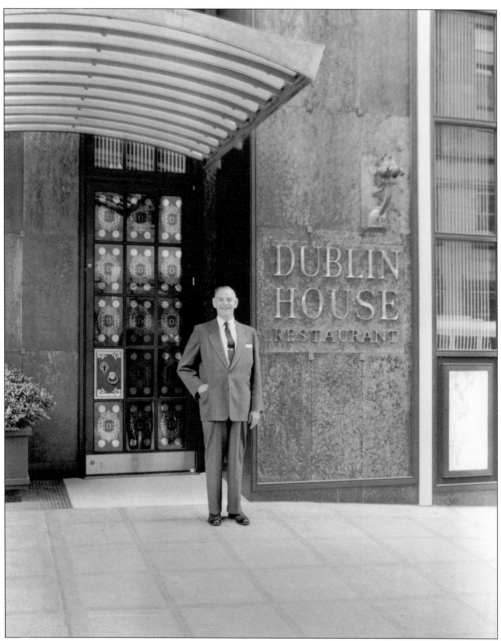

WALTER CLARK OUTSIDE DUBLIN HOUSE. This 1960 photograph shows Walter Clark standing in front of his Dublin House restaurant. The upscale dining establishment featured cherished items brought from Ireland. (Courtesy of the Bob Miller Collection, MOHAI, No. 2002.46.14.)

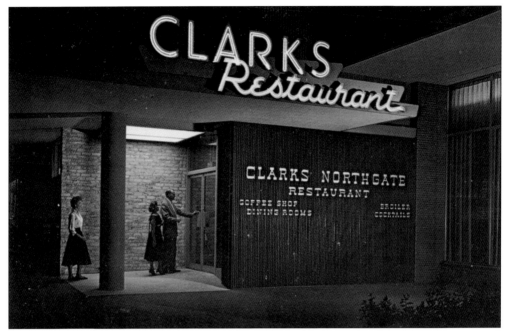

CLARK'S NORTHGATE RESTAURANT. On November 1, 1951, Clark's Northgate Restaurant opened in Northgate Shopping Center—way out of town at Eighty-fifth Street. At the time, critics wondered, "Who's going to go way out there to eat?" There was also a Feather Duster cocktail room decorated in a Gay Nineties theme. (Author's collection.)

CLARK'S

minute chef

1316 FOURTH AVENUE
SEATTLE, WASHINGTON

CLARK'S MINUTE CHEF MENU COVER. A quick-service coffee shop, the Clark's Minute Chef, opened on January 7, 1956. The restaurant seated 85 people, and one attorney claimed he could sit at the counter, order, and eat lunch in 22 minutes. (Courtesy of Nancy Leson, *Seattle Times.*)

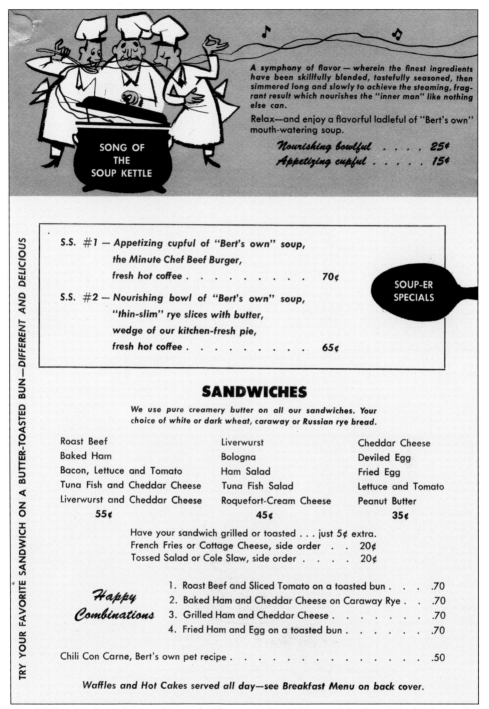

CLARK'S MINUTE CHEF MENU (INSIDE). The menu shows "Song of the Soup Kettle: A symphony of flavor—wherein the finest ingredients have been skillfully blended, tastefully seasoned, then simmered long and slowly to achieve the steaming, fragrant result, which nourished the 'inner man' like nothing else can." The menu also included "Soup-er Specials," simmered in 10-gallon stainless steel soup kettles near the entrance. (Courtesy of Nancy Leson, *Seattle Times*.)

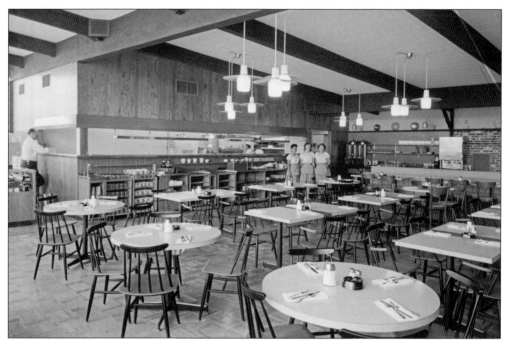

CLARK'S PANCAKE CHEF. Opening day for Clark's Pancake Chef was July 4, 1959, and the restaurant was located at the junction of the Seattle-Tacoma Highway at South 152nd Street. The decor was Swedish modern, and the business served breakfast, lunch, and dinner. The restaurant featured 6 types of waffles, 4 kinds of fritters, and 15 different kinds of pancakes. It usually had customers waiting to be seated. Dick Keller was the manager. (Courtesy of the Seattle Municipal Archives.)

THE RED CARPET RESTAURANT. Located at 1628 Fifth Avenue next to Frederick and Nelson was the Red Carpet Restaurant, which featured a continental broiler. Chef Frank Fleehart and manager Don Elliott ran the business. (Author's collection.)

THE RED CARPET MENU COVER. The restaurant opened on August 31, 1956, with 150 seats and luxurious red carpeting. The design of the menu coordinated with the restaurant's theme of lamps and candlesticks from a 19th-century tavern and antiques from Frederick and Nelson's Old World Shop. (Author's collection.)

Red Carpet Complete Dinners

(From Salad to Dessert)

Our Own Special Tossed Salad

(Au Gratin, French Fries or Baked)
Choice of Potatoes

Hot Rolls and Butter

Pink Lady Sherbet or Tarte au Jenkins
(A crunchy Coconut Torte with your favorite Ice Cream)

Coffee or Tea

YOUR CHOICE OF THE FOLLOWING ITEMS

ROAST PRIME RIB OF STEER BEEF 5.50

In their own delectable juices! Generous cut of choice beef—selected, aged and carved to your liking—rare, medium-rare or medium-well. Specialty of the house.

Extra thick cut 6.50

MINUTE NEW YORK STEAK 5.95

That prize steak—boneless sirloin strip—cut from the finest of beef in just the right size to go with our complete dinner. Broiled just as you like it, served sizzling hot.

BEEF STROGANOFF 4.25

Cubes of choice tenderloin simmered slowly till tender in butter, spices and sour cream served with fluffy white rice.

FILET OF KING SALMON 3.95

No royalty ever deserved the name more than this fine salmon, pride of the Pacific Northwest! We pan-broil it tenderly in wine and butter, the result—perfection!

DEEP SEA SCALLOPS, RED CARPET 3.35

These tender, delectable gifts from King Neptune pan-broiled in our special wine and butter sauce are a real taste treat. (Perfect with a glass of Sauterne wine!)

FILET OF SOLE, PUGET SOUND 3.35

Fresh from Puget Sound's cold waters, delicately pan-broiled in wine and butter.

BROILED LOUISIANA PRAWNS 3.75

Our flame-broiling in wine brings out the best in these delicious New Orleans giants!

BROILED HAM STEAK HAWAIIAN 3.85

Thick center cut of western style ham crowned with slice of Hawaiian pineapple and plump juicy prune, broiled to perfection with topping of brown sugar glaze.

THE RED CARPET MENU (INSIDE). Walter Clark told his managers to multiply the cost of the ingredients three times to arrive at a cost for a food item. The kitchen was kept spotless, and later a new women's restroom was added. (Author's collection.)

CLARK'S TOTEM CAFÉ MENU COVER. This menu cover featured a pink rhododendron flower, which is Washington State's state flower. The Totem Café opened in May 1947 at Pike Street and Fifth Avenue. An early sports bar for televised sports events, the café advertised good fellowship and a club-like atmosphere. (Author's collection.)

CLARK'S TOTEM CAFÉ MENU (INSIDE). On the menu were broiled steaks and chops with potatoes and hot rolls for $1.50 to $3.25. Totem clam chowder was only 25¢. A crab or shrimp Louie cost $1.50. Later, in 1954, the Totem Café was remodeled and renamed the Westerner with a lounge named the Saddle Horn. (Author's collection.)

TOTEM CAFE

Featuring
STEAKS
FROM OUR
ROTARY BROILER

STEAKS and CHOPS
with Potatoes and Hot Rolls

Tenderloin Steak	$3.25
Top Sirloin Steak	2.90
Chicken Fried Pounded Steak	1.45
Breaded Veal Cutlets	1.35
Loin Pork Chops (2)	1.50
French Lamb Chops (2)	1.90
Ground Round Steak	1.35
Pennsylvania Dutch Pork Sausage	1.20

TOTEM SPECIAL Hamburger Steak 1.65
Delicious Steak of Fresh Ground Round served on platter, garnished with Chili Con Carne, French Fried Potatoes and French Fried Onion Rings.

Broiled Half Spring Chicken Unjointed, on Toast 1.90

SEAFOODS . . .
Broiled "King" Salmon Steak 1.25
Broiled Halibut Steak 1.10
French Fried Jumbo Prawns 1.40

TOTEM SPECIAL 1.70
A broiled delicious steak of "King" Salmon, centered with a Crab Cocktail, French Fried Potatoes and Cole Slaw.

SOUPS . . .
"Totem" Clam Chowder	.25
Clam Chowder with Meals	.15
Our Daily Soup	.25
Small Bowl Soup with Meals	.15
Chili con Carne	.50
(Made from a famous Spanish Recipe)

COCKTAILS . . .

Jumbo Crab Legs, Supreme85
Choice Jumbo Crab Legs with rich, spicy cocktail sauce and served with sliced lemon and saltines.

Alaskan Shrimp Meat85
From the cold clear waters off the Alaskan Coast.

Supreme Fruit Cocktail65

From the SALAD BOWL . . .

Crab Louie 1.50
Flakes of Dungeness Crab Meat over shredded crisp lettuce, topped with 1000 Island Dressing and garnished with Jumbo Crab Legs, Hard Boiled Eggs, Tomato, Green Pepper Rings and Ripe Olives.

Shrimp Louie 1.50

Doctor's Salad95
Creamy Cottage Cheese on Crisp Hearts of Lettuce, topped with French Dressing and garnished with American Cheese, Tomato, Green Pepper Rings and Ripe Olives.

Dungeness Crab Meat	.95
Alaskan Shrimp Meat	.95
Combination Vegetable Salad	.85
Combination Fruit Salad	.95
Head Lettuce and Sliced Tomatoes	.70

We Assume No Responsibility for Lost Articles

SANDWICHES . . .

"French-Dipt" Sandwich70
Slices of choice beef served on a special French Roll dipped in natural beef juices.

Hot Corned Beef on Rye70
Choice slices of Corned Brisket of Beef served on genuine Caraway Rye Bread.

"Totem" Special Hamburger Sandwich45
Freshly ground round served on a toasted bun with mustard dressing, relish and crisp lettuce leaf.

"Totem" Cheeseburger	.55
Baked "Sugar-Cured" Ham Sandwich	.55
Hot Roast Beef Sandwich	.75
Imported Swiss Cheese on Rye	.40
Sliced Turkey Sandwich	.75
Chicken Salad Sandwich	.45
Combination Cold Ham and Cheese	.65
Tuna Fish Sandwich	.45
Egg Salad Sandwich	.35
Lettuce and Tomato Sandwich	.35
Toasted Cheese Sandwich	.35
Toasted Cheese and Tomato	.45
Bacon and Tomato	.60
"Totem" Club House	1.00

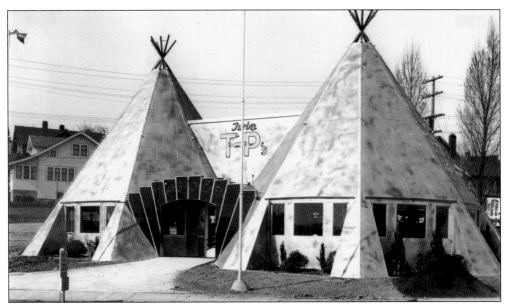

CLARK'S TWIN T-P'S. Before the 1920s, people traveling by car had few places to eat along the open road. This changed during the 1920s and 1930s. As more people bought cars, restaurant and hotel owners tried to attract business by constructing eye-catching buildings along major roadways. One of these was Clark's Twin T-P's restaurant, which opened in Seattle in 1937. (Courtesy of MOHAI, No. 83.10.17,115.1.)

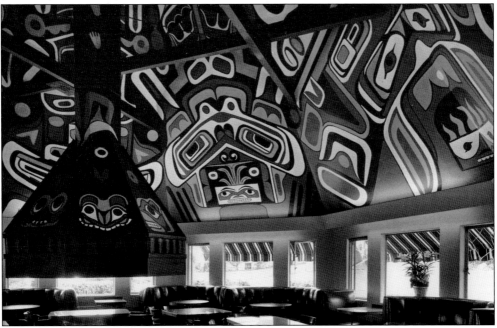

CLARK'S TWIN T-P'S, INTERIOR. This photograph shows the interior of Clark's Twin T-P's restaurant on Aurora Avenue in Seattle in 1951. The business was one of a half dozen Clark's restaurants in the city, all of which served family meals at a reasonable price. None of Clark's other buildings was quite as unusual as this one. It featured Northwest Coast Indian designs on the interior and a Plains Indian design on the exterior. (Courtesy MOHAI, No. 1983.10.18141.2.)

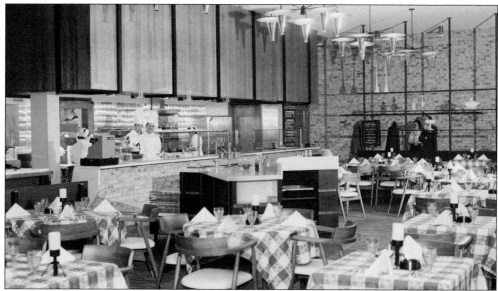

CLARK'S VILLAGE CHEF. This restaurant opened on February 7, 1957, in University Village at the intersection of Twenty-fifth Avenue NE and Northeast Forty-fifth Street. The tables were covered with a blue-and-white checkered tablecloth, and waitresses wore Dutch schoolgirl uniforms. Children ordered from a menu shaped like a clown's head, and sundaes featured lighted sparklers. Vernon Wiard was the manager, and Meigs Close was the supervisor who helped make this restaurant successful for Clark. (Courtesy of the Seattle Municipal Archives.)

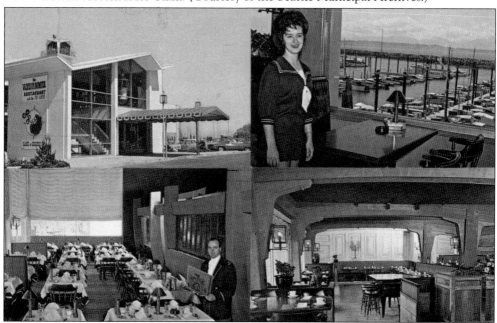

WINDJAMMER RESTAURANT. This postcard is of the Clark's Windjammer Restaurant, with its handsome decor recalling old-time sailing ships. It overlooked the picturesque Shilshole Bay Yacht Marina and had a sweeping view of the Olympic Mountains and Puget Sound. Charcoal-broiled steaks and gourmet seafood were served. It was open for dinner and dancing as well as entertainment, with complimentary parking and moorage. (Author's collection.)

Seven

NORTHWEST FAVORITES

Northwest favorites are historic places. Some are still here and visualize a romantic past. Some have been left by the wayside on the quest to jump into the future. These are the restaurants where locals loved to eat when the businesses were in their heyday.

Mount Rainier National Park was established on March 2, 1899, and is the most visited landmark in Washington State. The mountain is an active volcano and encompasses 235,625 acres. The Paradise Inn Dining Room features a bourbon buffalo meatloaf and offers views of the mountain's majestic scenery.

The Space Needle is a major landmark in the Pacific Northwest and was built for the 1962 Seattle World's Fair. It was the tallest structure west of the Mississippi River. It weighs 9,550 tons, is 138 feet wide, and 605 feet tall. The Sky City Restaurant is 500 feet high and revolves with views around the city. Even Elvis Presley visited the Seattle Center.

Other much loved sites show off the wondrous coastal beauty of the Olympic National Park, with its Kalaloch Lodge and Lake Quinault Lodge. Visitors can have "high tea" with the rich and famous at the historic Empress Hotel in Victoria, British Columbia's capital city, on Vancouver Island.

Seattle visitors can enjoy these Northwest favorites if not in person then in spirit by viewing these historical photographs and reading about their wonderful histories.

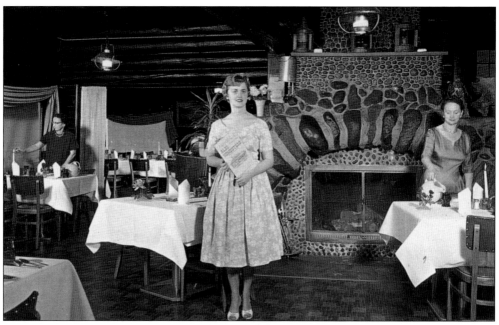

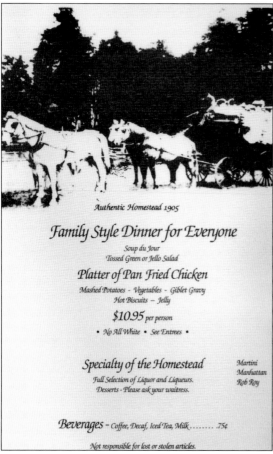

Authentic Homestead 1905

Family Style Dinner for Everyone

Soup du Jour
Tossed Green or Jello Salad

Platter of Pan Fried Chicken

Mashed Potatoes - Vegetables - Giblet Gravy
Hot Biscuits – Jelly

$10.95 per person

• No All White • See Entrees •

Specialty of the Homestead

Full Selection of Liquor and Liqueurs.
Desserts - Please ask your waitress.

Martini
Manhattan
Rob Roy

Beverages - Coffee, Decaf, Iced Tea, Milk75¢

Not responsible for lost or stolen articles.

ALKI HOMESTEAD. Just a few steps from this building, on November 13, 1851, the schooner *Exact* landed on Alki Beach with a small party of settlers. In 1902, Mr. and Mrs. William J. Bernard began building Fir Lodge and lived there from 1904 to 1907. But it was Doris Nelson who, in 1960, gave the lodge the ambiance that it still has today. (Courtesy of the Southwest Seattle Historical Society.)

ALKI HOMESTEAD MENU (INSIDE). The menu has not changed much over the years. The decor is Victorian, with lace tablecloths and crystal chandeliers. The business is known for its family-style pan-fried chicken dinner. On July 21, 1907, the Seattle Driving and Auto Club bought the homestead to use as a destination to drive to. The homestead is still open at 2717 Sixty-first Avenue SW. (Courtesy of the Southwest Seattle Historical Society.)

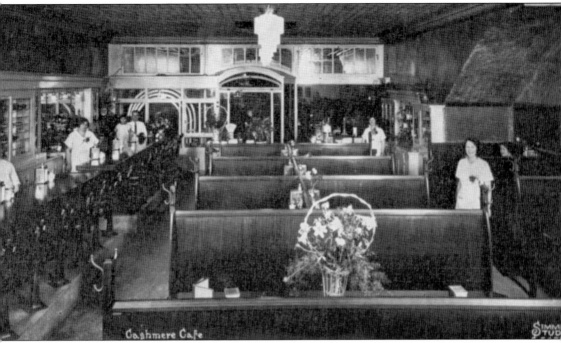

Cashmere Cafe

CASHMERE CAFÉ. At the beginning of the 20th century, a young Armenian named Armen Tertsagian immigrated to the United States where he met another young Armenian, Mark Balaban, and they went into business together. They purchased an apple farm, which they named Liberty Orchards. They also perfected a delectable apple and walnut recipe, "Confection of the Fairies," also known as applets. In 1920, they opened Cashmere Café and Confectionery, located in Cashmere, Washington. As shown in the postcard, the restaurant was clean and served appetizing food with the best service. Currently, the renamed Cashmere Applets and Cotlets offers tours and has a wonderful gift shop. (Author's collection.)

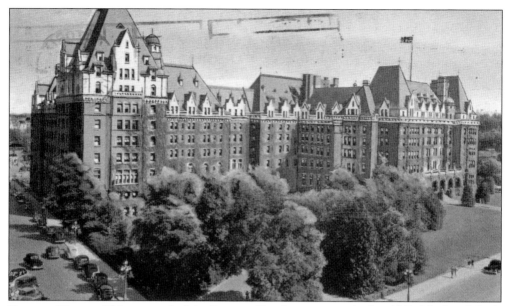

EMPRESS HOTEL. This postcard of the Empress Hotel was postmarked in 1949. The hotel, built between 1904 and 1908, is one of the oldest and most famous hotels in Victoria, British Columbia, Canada. The hotel has 477 rooms. (Author's collection.)

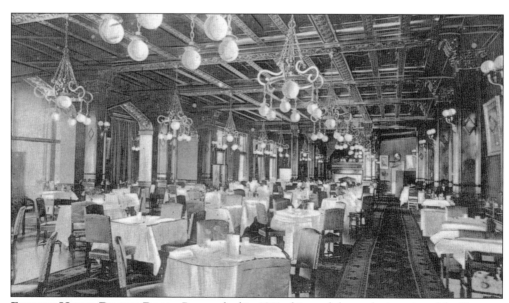

EMPRESS HOTEL DINING ROOM. Postmarked in 1911, this card shows the interior of the Empress Hotel dining room. Shirley Temple stayed at the Empress in the 1930s with her parents because of kidnapping threats. (Author's collection.)

EMPRESS HOTEL MENU. Pictured here is a four-page menu from the Empress Hotel, dated July 20, 1939. The hotel is well known for its classic Edwardian afternoon tea service for approximately $50 Canadian. Today the restaurant serves tea in the "Tea Lobby" to more than 800 tourists and guests. (Author's collection.)

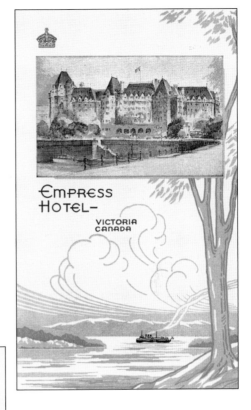

HORS D'OEUVRES
Ripe or Green Olives 25 Sardines, tin 50 Celery 35 Canape Caviar 80 Antipasto 60
Hors d'Oeuvres Varies 1.00 Fruit Cocktail 40 Tomato Juice 20

SOUPS
Consomme Brunoise 20, cup 15 Scotch Broth with Barley 20, cup 15
Green Turtle, cup 40 Cream of Tomato 30 Chicken Okra 30 Chicken Broth with Rice 30

FISH
Fried Julienne of Sole, Tartare Sauce 70 Broiled Filet of Codfish with Bacon 60

THE EMPRESS is famous for its CRAB LOUIE, 80 cents

Shrimp Cocktail 50 Crab Cocktail 50

ENTREES
Curried Poached Egg with Rice, Chutney 55 Breaded Lamb Chops, Tomato Sauce 65
Casserole of Spaghetti Caruso 60 Canadian Pot Roast, Potato Pancakes 70
Cold Plate Lunch with Swiss Cheese 65 Jellied Chicken with Waldorf Salad 70
Cold Roast Lamb, Mint Jelly, Salade duBarry 75

ROAST
Loin of Pork, Apple Sauce 70

FROM THE GRILL
Single Sirloin 1.30, Double 2.60 Chateaubriand (for 2) 3.00 Filet Mignon Nature 1.40
Minute Steak 1.20 Small Tenderloin 1.40 T-bone Steak (1) 1.75 Lamb Chops 85

COLD MEATS
Prime Ribs of Beef 85 Pressed Beef 60 Assorted Meats 90, with Chicken 1.00
Galantine of Chicken 80 Sliced Chicken 1.00 Headcheese, Cole Slaw 60
Veal and Ham Pie, Salade Bernoise 75 Virginia Ham 90 Lamb 75

VEGETABLES
New Potatoes in Cream 30 New String Beans 40
Cauliflower 30 Fresh Spinach 25 Sweet Potatoes 35, Southern Style 50
New Peas 45 Stuffed Tomatoes 40 Stewed Fresh Tomatoes 40
Potatoes in Cream 25, Persilles 20, Rissoles 20, Hashed Browned 20

SALADS
Lettuce and Tomato 45 Crabflake 80 Shrimp 90 Fruit 65 Asparagus Tip 55
Tomato Surprise 60 Combination 60 Chicken 1.00
DRESSINGS – Russian 25 Roquefort 25 Thousand Islands 15

SWEETS
Sago and Apple Pudding 20 Raspberry Shortcake 25 Pineapple Tartlet 15
Vanilla, Coffee, or Chocolate Ice Cream 30 Sherbets 25

FRUIT
Casaba Melon 35 Sliced Peaches and Cream 35 Water Melon 35 Half Cantaloupe 35
Fresh Raspberries and Cream 40 Apple 10 Banana 10 Compote of Fruit 50

CHEESE
Canadian Stilton 20 Imported Gorgonzola 25 Imported Roquefort 35 Dutch 25
McLaren's 25 English Stilton 35 Imported Gruyere 30 Ferera 25
Sooke Brick 25 Empress Cream Cheese with Grape Jelly 30

TEA, COFFEE, AND MILK
Tea or Coffee 20 Demi-Tasse 15 Kaffee Hag 20 Sanka Coffee 20 Ovaltine 25
Glass of Milk 10 Glass Milk, Half Cream 25 Jersey-Holstein Milk, bottle 15
Malted Milk 25 'Mountain View' Guaranteed Jersey Milk, per bottle 20

Single portions served to one person only July 20, 1939

EMPRESS HOTEL MENU (INSIDE). Every Saturday evening in the ballroom one could dance to a 10-piece orchestra and have supper for $1.25. The front entrance did not have a sign for many years. Victorians and hotel guests evoked strong emotions, as one worker expressed while raising a new sign above the door, "Anyone who doesn't know this is the Empress shouldn't be staying here." (Author's collection.)

KALALOCH LODGE LOUNGE. Nestled in the Olympic Peninsula is the Kalaloch Lodge, built in 1938. This coastal land was aptly named Kalaloch, or "land of plenty," by the Quinault Indians. The late afternoon view of the Pacific Ocean is one of the attractions of this renowned resort. (Author's collection.)

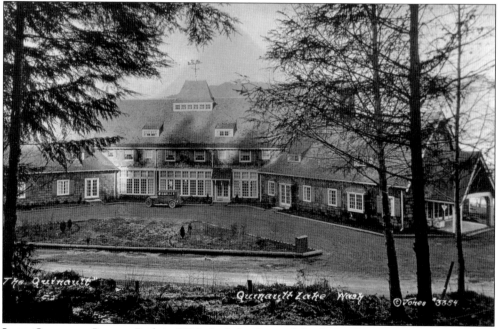

LAKE QUINAULT LODGE. Built in 1926, the Lake Quinault Lodge, with its massive brick fireplace and native Northwest art adorning the beams, is a Seattle retreat to the Olympic rainforest. Pres. Franklin D. Roosevelt visited Lake Quinault Lodge on October 1, 1937, and nine months later the Olympic National Park was born. (Courtesy of Mary Patterson.)

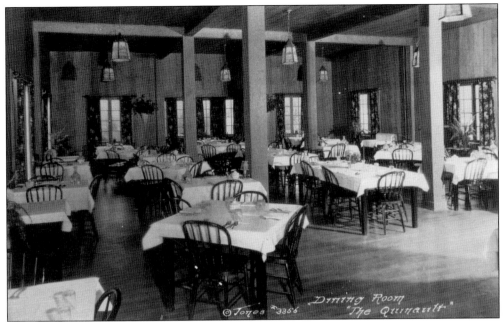

LAKE QUINAULT LODGE DINING ROOM. The lodge's dining room is now called the Roosevelt Dining Room in honor of Pres. Franklin D. Roosevelt. A photograph of President Roosevelt dining at this historic retreat hangs on the dining room wall. (Courtesy of Mary Patterson.)

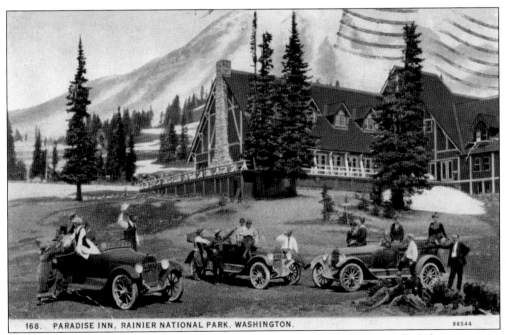

PARADISE INN, RAINIER NATIONAL PARK. The Puyallup Indians first called this mountain Talol, or Tahoma, from the Lushootseed word meaning "mother of waters." Mount Rainier was established as a national park on March 2, 1899. Paradise Inn is depicted in the postcard above. (Author's collection.)

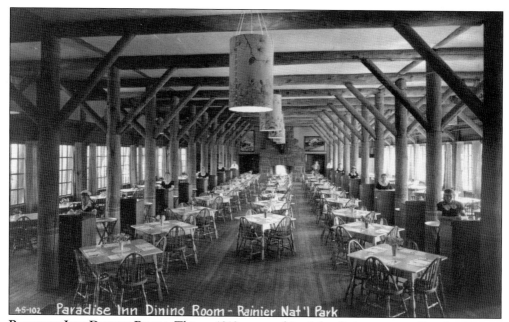

PARADISE INN DINING ROOM. This *c.* 1919 postcard is of the dining room at Paradise Inn on Mount Rainier. Notice the waitresses at their side stations posing for the photograph, which was taken by Ashael Curtis. (Author's collection.)

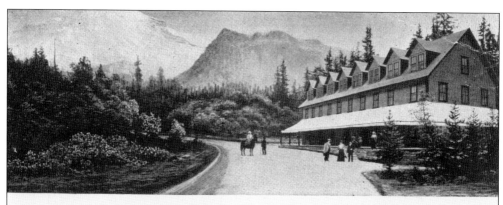

NATIONAL PARK INN, LONGMIRE SPRINGS, MT. RAINIER

WHY NOT SPEND A DAY ON MOUNT RAINIER? Are you aware that you can leave your office at 11.30 a.m. and dine at the NATIONAL PARK INN, situated at Longmire Springs, at the very base of Mt. Rainier, at 7 p.m. Think of it! This grand old mountain only a few hours away! Next Saturday catch the 12 noon Interurban, for Tacoma, get off at the Tacoma Eastern Depot, take the 1.30 p.m. train for Longmire Springs, spend all day Sunday in Paradise Valley among the wild flowers, or exploring the Glaciers. Returning Monday, arriving in Seattle at 2.40 p.m. Total expense $11 cheaper than staying at home. Let us tell you about it. Write SAMUEL WILSON. G. F. & P. A., Tacoma Eastern Railroad, Tacoma, Wash., or see E. C. RICHMOND. T. F. & P. A., 517 Second Avenue, Seattle, Wash.

NATIONAL PARK INN, LONGMIRE SPRINGS. Originally, Paradise Inn was called National Park Inn, as depicted in the postcard above. Mount Rainier has always been a favorite Seattle resort and currently is the most visited place in Washington State. (Author's collection.)

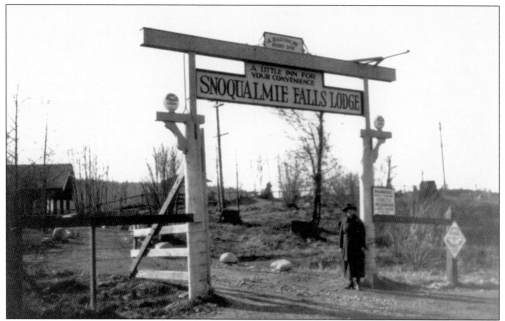

SNOQUALMIE FALLS LODGE ENTRANCE. Jennie Jarrett stands under the Snoqualmie Falls entrance sign in this *c.* 1917 photograph. The sign in the photograph says, "A rainbow every day," and "A little Inn for your convenience." The photograph was donated to the Snoqualmie Valley Museum by Robert and Marie Jarrett. (Courtesy of the Snoqualmie Valley Historical Museum.)

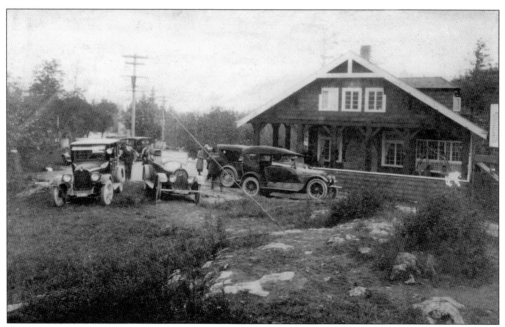

SNOQUALMIE FALLS LODGE. This 1920s photograph of the Snoqualmie Falls Lodge was donated to the Snoqualmie Valley Historical Museum by longtime resident Nels Nelson. The original building, including the brick fireplace in the main dining room, above Snoqualmie Falls is still part of the updated Salish Lodge. (Courtesy of the Snoqualmie Valley Historical Museum.)

Snoqualmie Falls, Washington.

SNOQUALMIE FALLS POSTCARD.
Snoqualmie Falls is shown during the spring runoff in the 1910s prior to the building of the Snoqualmie Falls Lodge. To make the falls accessible by automobile, the Sunset Highway was built in the early 20th century from Kirkland. A power plant was built in 1898 and operates at the base of the falls, 270 feet below the surface. This power plant was the world's first underground electrical plant. (Author's collection.)

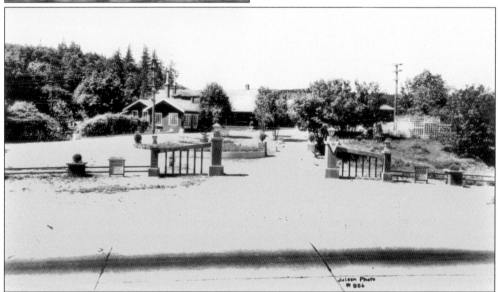

SNOQUALMIE FALLS LODGE. This postcard shows the original Snoqualmie Falls Lodge that overlooked the sacred 276-foot-tall waterfall. The Snoqualmie tribe believes that Snoqualm, or Moon the Transformer, created the world and the falls. On June 3, 1988, the elegant Salish Lodge, formerly the Snoqualmie Falls Lodge, held a grand reopening. Snoqualmie Falls is the second most visited tourist attraction in Washington State. (Author's collection.)

SNOQUALMIE FALLS LODGE BROCHURE. The Snoqualmie Falls Lodge, "A Northwest Dining Tradition Since 1916," was located about 30 miles east of Seattle. The restaurant was known for its "World Famous Farm Breakfast." It also served a "Family Style Fried Chicken Dinner" on Sundays. (Author's collection.)

SNOQUALMIE FALLS LODGE BROCHURE. Author Robin Shannon once was a waitress at the lodge and wore a "country farm girl" outfit while pouring "Honey from the sky" over buttermilk biscuits (depicted in this brochure). The brick fireplace from the original Snoqualmie Falls Lodge has been retained and is part of the modern Salish Lodge. (Author's collection.)

Breakfast

All Breakfasts Include:
A selection of fresh fruit (including strawberries with Devonshire cream), fresh-squeezed orange juice and Washington apple juice. hot oatmeal with fresh cream and brown sugar, fresh fruit muffins (baked every half hour) with honey-butter, freshly brewed coffee, a selection of teas, hot chocolate or ice-cold milk.

Entreé Selections

The Salish Hunter
Fresh Cascade brook trout with our own game sausage, fresh eggs prepared any style, grilled potatoes and sourdough biscuits.
18.50

Lumberman's Breakfast Steak
Center-cut tenderloin of beef served with fresh eggs prepared any style, grilled potatoes and sourdough biscuits.
19.50

Ballard Smoked Salmon
A special blend of eggs whipped with smoked salmon, cream cheese and capers. Served with sweet onions, warm bagels and a smoked salmon rosette.
17.95

Country Breakfast
Our own apple-pork sausage, smoked bacon and country-style ham, served with fresh eggs prepared the way you like them, grilled potatoes and sourdough biscuits.
16.95

Eggs Florentine
Poached egg on a bed of fresh pan-steamed spinach blended with cream sauce, served on a puff pastry and topped with Hollandaise. Served with grilled potatoes and sourdough biscuits.
17.50

Shrimp Avocado
Light and fluffy eggs served with fresh avocado, tomato and Oregon bay shrimp, laced with Jack cheese. Served with grilled potatoes and sourdough biscuits.
16.95

Washington state sales tax not included.
Operated by Salishan Lodge

SALISH LODGE MENU. A menu from the Salish Lodge at Snoqualmie Falls *c.* 1988 is shown here. All breakfasts at the Snoqualmie Falls Lodge and in the early days of the Salish Lodge included a selection of fresh fruit. Author Robin Shannon remembers serving a huge plate of various succulent melons, strawberries with Devonshire cream, blueberries, blackberries, raspberries, and fresh-squeezed juice for the first course. (Author's collection.)

ELVIS PRESLEY AT THE MONORAIL STATION. Elvis Presley presents a ham from Presley's Tennessee farm to Washington governor Albert Rosellini on September 5, 1952. Presley was in Seattle to make his 11th motion picture, *Take Me to the Fair.* He is pictured with Gov. Albert Rosellini (left); Ted Richmond (second from left), the producer of the movie; and Norman Taurog (right), the director. (Courtesy of the *Seattle Post-Intelligencer* Collection, MOHAI, No. 1986.5.40806.2.)

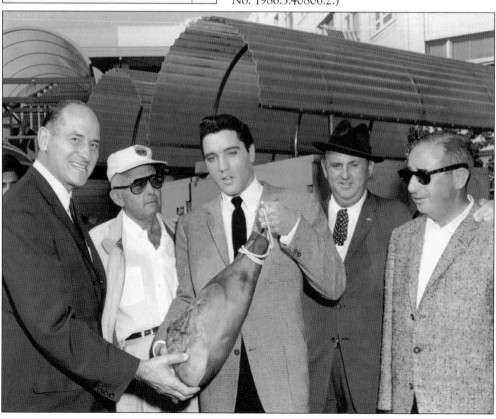

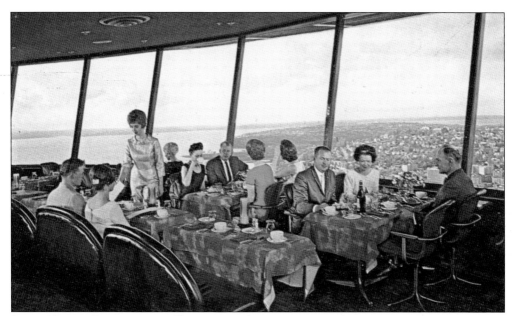

SPACE NEEDLE RESTAURANT. The interior of the Space Needle Restaurant is shown in this 1960 postcard. The diners enjoy a continuous panorama of the city of Seattle as they revolve around the entire circle every hour. The Space Needle was the tallest building west of the Mississippi River when it was built in 1961 and is still Seattle's No. 1 tourist destination. (Author's collection.)

SPACE NEEDLE RESTAURANT MENU (INSIDE). In 1959, Edward E. Carlson, inspired by the Stuttgart Tower in Germany, sketched his vision of a dominant structure for the 1962 Seattle World's Fair on a place mat in a coffee house. On April 21, 1962, the Space Needle, which was built for $4.5 million, opened on the first day of the World's Fair. (Author's collection.)

A La Carte Selections

The scene from your commanding table on the rim of the slowly circling disk will add delight to these outstanding foods. At night, under the stars, you can even imagine yourself on a voyage in space.

NEW YORK CUT SIRLOIN STEAK, CHASSEUR
The finest Western beef, cut thick and broiled over glowing embers to perfection, crowned with sauteed chanterelle mushrooms 6.65
BEEFEATER EXTRA THICK CUT 8.30

BROILED TAILS OF PACIFIC LOBSTER
Superb lobster tails broiled on the shell and served with drawn butter 7.75
FILET STEAK AND BROILED LOBSTER TAIL 8.95

VEAL STEAK, CORDON BLEU
A generouse slice of milk-fed veal, filled with a delightful blend of Swiss cheese and ham, then pan fried to a golden brown 5.75

FROG LEGS, FRANCAISE
Fried to a golden brown with a rich Bearnaise sauce, a pinnacle of delectability 5.50

FILET MIGNON
A choice steak from the most desirable of all red meats, broiled to your preference and garnished with a rosette of beurre maitre d'hotel 6.95
PETIT CHATEAUBRIAND, BOUQUETIERE, BEARNAISE SAUCE 8.80

SEAFOOD DUO
Delicately stuffed king prawns and Dungeness crab legs, flavored with sherry and dry mustard, served with wild rice, sauce diablo 6.55

LAMB EN BROCHETTE
We combine tender slices of marinated lamb, bacon, mushroom, green pepper, onion and tomato broiled gourmet style. Saffron rice is served with this dish of Turkish origin 5.95

FILET STEAK AND SALMON COMBINATION
A new experience in fine dining, fresh filet of Puget Sound Salmon and filet steak served with rice and broiled tomato, garnished with green pepper and mushroom sauce 6.55

ROAST PRIME RIBS OF WESTERN BEEF
An identical thick slice of the same red juicy beef as offered with the complete dinner . . . for those who prefer to order a la carte 5.95
CHOICE CATTLEMEN'S CUT 6.95

BREAST OF CHICKEN, ORIENTAL
Boned breast of chicken filled with a delightful blend of fresh apples, roasted almonds, raisins and a whisper of exotic spices 5.45

BREAST OF CHICKEN, PRINCESS
Boned breast of chicken stuffed with fresh mushroom and cream cheese, topped with a delicious sour cream sauce, flavored with sherry 5.45

FILET OF PUGET SOUND SALMON
The pride of the Pacific, fresh from the surrounding waters,

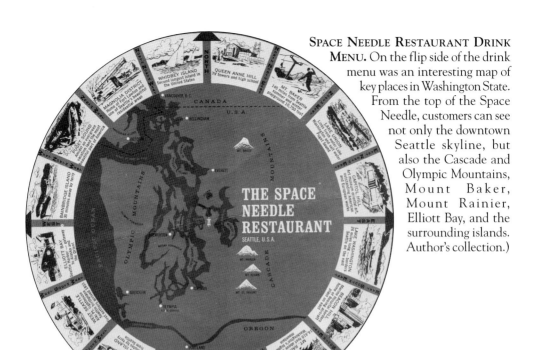

SPACE NEEDLE RESTAURANT DRINK MENU. On the flip side of the drink menu was an interesting map of key places in Washington State. From the top of the Space Needle, customers can see not only the downtown Seattle skyline, but also the Cascade and Olympic Mountains, Mount Baker, Mount Rainier, Elliott Bay, and the surrounding islands. Author's collection.)

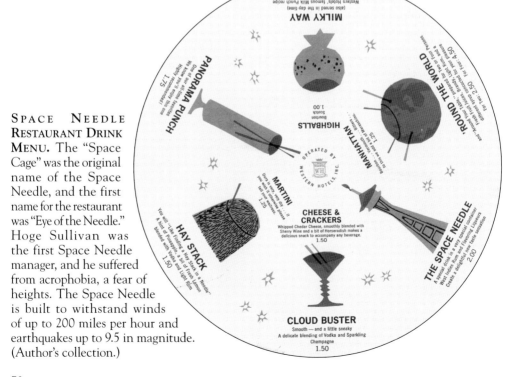

SPACE NEEDLE RESTAURANT DRINK MENU. The "Space Cage" was the original name of the Space Needle, and the first name for the restaurant was "Eye of the Needle." Hoge Sullivan was the first Space Needle manager, and he suffered from acrophobia, a fear of heights. The Space Needle is built to withstand winds of up to 200 miles per hour and earthquakes up to 9.5 in magnitude. (Author's collection.)

Eight

CRÈME DE LA CROP

The crème de la crème of Seattle does not necessarily mean the fanciest restaurants, although those are a big part of this section. These are haunts that Seattleites have enjoyed through the years.

The Pacific Northwest is rich in sea fare; broiled salmon is one of the biggest sellers. Another big seller is Dungeness crab from Anacortes. Pan-fried Olympia oysters and oysters Rockefeller are served fresh in the Northwest. Quilcene oysters, which got their start in Japan, are on several menus in the area. Clams from Puget Sound, which were eaten by the Native Americans, are still a favorite today. There are also the razor clams, rock clams, butter clams, and the geoduck (gooey duck). Local Native Americans used to collect barnacles and boil them for their chiefs as a delicacy, but they will not be found on any menu here now.

The geoduck, native to the Pacific Northwest, is the largest burrowing clam in the world, weighing in between one and three pounds. It has a life expectancy of about 146 years and sells for more than $30 a pound in Asia. In Washington, it is about the ugliest clam ever seen and is usually made into the tastiest clam chowder ever eaten.

New England and Manhattan clam chowder are probably on almost everyone's menu in the Pacific Northwest. In the 1950s, Canlis offered a mahimahi chowder (Canlis's Own Hawaiian Chowder) for $1.25, and today the Canlis chowder (made from Dungeness crab, prawns, and Manila clams in ginger-scented cream) is offered for $11.

Seattleites and visitors alike have enjoyed fresh seafood paired with charcoal broilers for some time. While restaurants have come and gone, a few have stood the test of time.

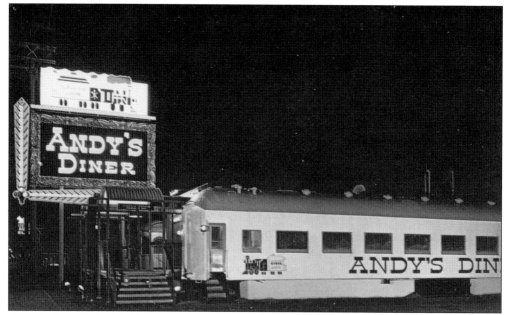

ANDY'S DINER. Andy's Diner originally was opened in 1949 by Andy Nagy. Bill Howard (one of three partners) bought the diner in July 2000. After being open for more than 50 years, it closed its doors in January 2008. Roger Shannon said, "I used to go to lunch there twice a week. "Big Andy" Nagy weighed 120 pounds, and his son, known as "Little Andy," weighed more than 250 pounds." (Courtesy of John Cooper.)

ANDY'S DINER, INSIDE. On March 13, 1956, unidentified diners and waitresses are pictured in the Club Car at Andy's railroad car diner, located at 2723 Fourth Avenue South in Seattle. Historic railroad pictures lined the walls. A charcoal broiler was in the center of all of the activity. (Courtesy of the Seattle Municipal Archives, No. 53137.)

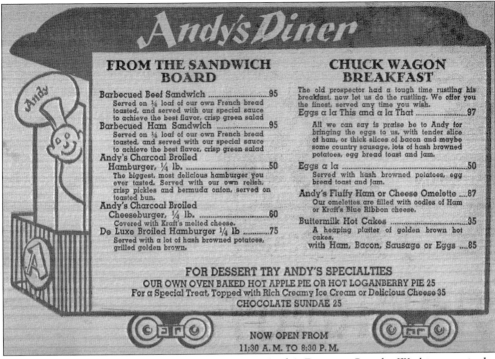

Andy's Diner

FROM THE SANDWICH BOARD

Barbecued Beef Sandwich95
 Served on ¼ loaf of our own French bread
 toasted, and served with our special sauce
 to achieve the best flavor, crisp green salad

Barbecued Ham Sandwich95
 Served on ¼ loaf of our own French bread
 toasted, and served with our special sauce
 to achieve the best flavor, crisp green salad

Andy's Charcoal Broiled
 Hamburger, ¼ lb.50
 The biggest, most delicious hamburger you
 ever tasted. Served with our own relish,
 crisp pickles and bermuda onion, served on
 toasted bun.

Andy's Charcoal Broiled
 Cheeseburger, ¼ lb.60
 Covered with Kraft's melted cheese.

De Luxe Broiled Hamburger ¼ lb75
 Served with a lot of hash browned potatoes,
 grilled golden brown.

CHUCK WAGON BREAKFAST

The old prospector had a tough time rustling his
breakfast, now let us do the rustling. We offer you
the finest, served any time you wish.

Eggs a la This and a la That97
 All we can say is praise be to Andy for
 bringing the eggs to us, with tender slice
 of ham, or thick slices of bacon and maybe
 some country sausage, lots of hash browned
 potatoes, egg bread toast and jam.

Eggs a la ..50
 Served with hash browned potatoes, egg
 bread toast and jam.

Andy's Fluffy Ham or Cheese Omelette87
 Our omelettes are filled with oodles of Ham
 or Kraft's Blue Ribbon cheese.

Buttermilk Hot Cakes35
 A heaping platter of golden brown hot
 cakes.
 with Ham, Bacon, Sausage or Eggs85

FOR DESSERT TRY ANDY'S SPECIALTIES
OUR OWN OVEN BAKED HOT APPLE PIE OR HOT LOGANBERRY PIE 25
For a Special Treat, Topped with Rich Creamy Ice Cream or Delicious Cheese 35
CHOCOLATE SUNDAE 25

NOW OPEN FROM
11:30 A. M. TO 8:30 P. M.

ANDY'S DINER MENU. This wooden menu says, "Andy's Diner in Seattle, Washington, is the outstanding diner west of the Mississippi river . . . featuring only the finest eastern corn-fed beef available. A trip to Seattle isn't complete unless you make Andy's Diner your mealtime headquarters. From the Charcoal Broiler; a prime favorite in every gourmet center of the world—the tenderest, most nutritious cuts of meat in the world. Call SE 4295." (Author's collection.)

BEN
PARIS
RESTAURANT

•

"Sportsman's
Headcamp"

•

In Seattle
at
1609
Westlake
Avenue
MA. 2-5730

BEN PARIS RESTAURANT. This undated postcard shows the Ben Paris Restaurant, which was located at 1609 Westlake Avenue. A quote on the back reads, "The world-famous Ben Paris Restaurant in Seattle is truly the sportsman's family headquarters for delightful dining in an atmosphere giving you that great outdoor feeling. Complete line of sporting goods for the fisherman or hunter and the latest dope. Tobacco, pipes and the Sportsman's Cocktail Lounge." (Author's collection.)

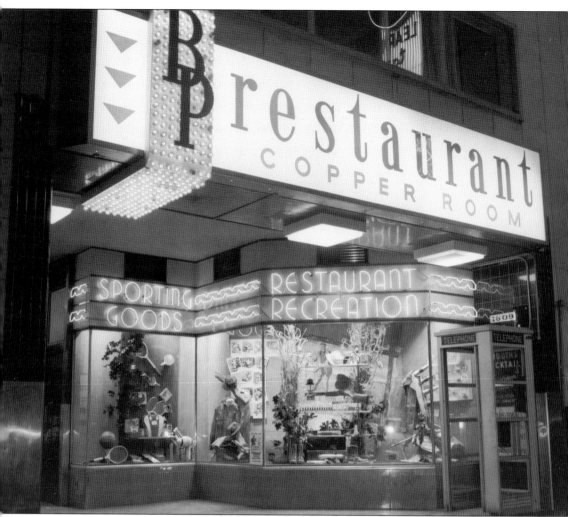

BEN PARIS RESTAURANT, 1959. The Ben Paris Restaurant was a Seattle institution for many years. It was a combination of a restaurant, bar, pool hall, and sporting goods store. It was located on the northeast corner of Fourth Avenue and Pine Street on the lower level of the Eitel Building. In the late 1920s, Ben Paris's Terminal Concessions Company and Bartell Drugs entered mutually into a 76-year lease of the Eitel Building. In 1946, the Eitel Building was sold to L. E. Nudelman. In 1948, Bartell Drugs and Ben Paris still occupied the street fronts. (Courtesy of the Robert H. Miller Collection, MOHAI, No. 1959 2002.46.10.)

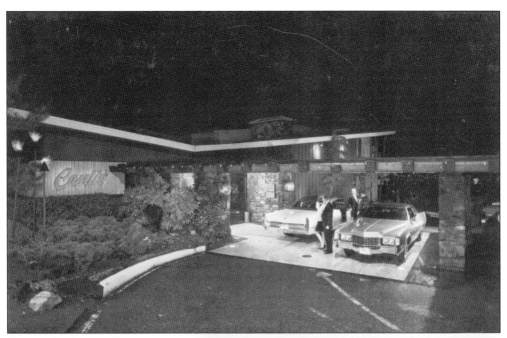

CANLIS CHARCOAL BROILER.
Featured on the postcard
above is an exterior view of
the Canlis Charcoal Broiler. In
1949, Canlis became the most
expensive restaurant built in the
past 30 years. It is still located
at 2576 Aurora Avenue North.
(Courtesy of R.V. Parks.)

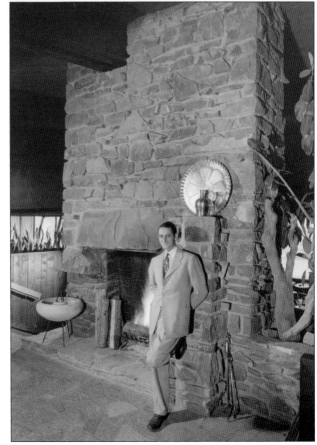

PETER CANLIS. Before long,
the name Canlis had become
synonymous with fine dining in
four major cities: San Francisco,
California; Honolulu, Hawaii;
Portland, Oregon; and Seattle,
Washington. The Seattle
location was the crown jewel for
Canlis. It was here that Canlis
introduced fine dining to a city
that had never had a dinner
house, an a la carte menu, or
liquor by the drink. (Courtesy
of Canlis.)

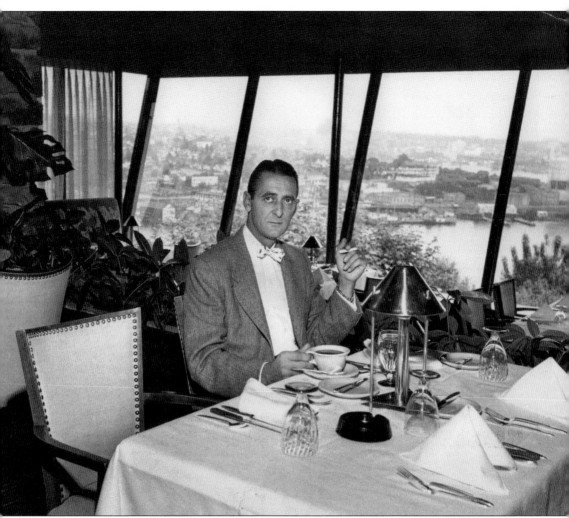

PETER CANLIS DINING. Peter Canlis's life story is that of the Canlis restaurants. Peter Canlis was flamboyant and hardworking, and he set out to make a name for himself. Quoted from the Canlis Web site is the following: "Great Grandpa Nicholas Peter Canlis was a wild hare. Born in Greece in 1881 under the Ottoman Empire, he set off to make his fortune. Moving through Constantinople and ending up in Egypt, he took work at the Mena House, Cairo's most famous hotel. The Mena always attracted the rich and the powerful. Winston Churchill, Charlie Chaplin, the Aga Khan, and Omar Shariff were all regulars at the hotel." Author Robin Shannon's favorite hotel is also the Mena House. Another quote from the Canlis Web site says, "Fifty years later, Peter Canlis's jewel is marvelously run by the next generation of family restaurateurs, Brian and Mark Canlis, preceded by their parents Chris and Alice. Together, they have preserved the traditions of this famous landmark while adding their creativity and energy to Canlis." (Courtesy of Canlis.)

CANLIS MENU. Canlis was the first Pacific Northwest restaurant to feature an open charcoal grill where guests could watch chefs grilling prime, Midwest, dry-aged steaks; king salmon; and fresh Pacific mahimahi over Kiawe charcoal brought in from Hawaii. In an era when "a la carte" was unheard of in the West, Canlis introduced Seattleites to the "Gargantuan Idaho Baked Potato—tubbed, scrubbed, and old-rubbed" at the astronomical cost of 50¢. (Author's collection.)

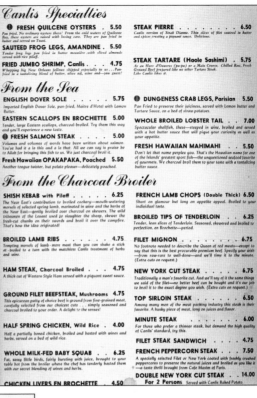

Canlis Specialties

FRESH QUILCENE OYSTERS . 5.50
Pan fried. No ordinary oysters these! From the cold waters of Quilcene Bay, these oysters are raised with loving care. They are pan fried in butter and served on Toast.

SAUTEED FROG LEGS, AMANDINE . 5.50
Tender frog legs pan fried in butter meunière with sliced almonds served with rice pilaff.

FRIED JUMBO SHRIMP, Canlis . . . 4.75
Whopping big New Orleans fellows shipped especially to us . . . Pan-fried in a tantalizing blend of butter, olive oil, wine and—you guest!

STEAK PIERRE 6.50
Canlis version of Steak Diane. Thin slices of filet sauteed in butter and spices creating a piquant sauce. Delicious.

STEAK TARTARE (Haole Sashimi) . 5.75
As an Hors d'Oeuvres (pu-pu) or a Main Course, Chilled Raw, Fresh Ground Beef prepared like no other Tartare Steak. Like Canlis likes it.

From the Sea

ENGLISH DOVER SOLE 5.75
Imported English Dover Sole, pan-fried, Maitre d'Hotel with Lemon Butter.

EASTERN SCALLOPS EN BROCHETTE 5.00
Tender, large Eastern scallops, charcoal-broiled. Try them this way and you'll experience a new taste.

FRESH SALMON STEAK 5.00
Volumes and volumes of words have been written about salmon. You've had it a la this and a la that. All we can say is praise be to Allah for bringing this fish to us. We just charcoal broil it.

Fresh Hawaiian OPAKAPAKA, Poached 5.50
Another tongue twister, but palate pleaser—delicately poached.

DUNGENESS CRAB LEGS, Parisian 5.50
Pan Fried to preserve their juiciness, served with Lemon butter and Tartare Sauce, on a bed of straw potatoes.

WHOLE BROILED LOBSTER TAIL . . 7.00
Spectacular shellfish, these—steeped in wine, broiled and served with a hot butter sauce that will pique your curiosity as well as your appetite.

FRESH HAWAIIAN MAHIMAHI . . 5.50
Don't let that name perplex you. That's the Hawaiian name for one of the Islands' greatest sport fish—the unquestioned seafood favorite of gourmets. We charcoal broil to your taste with a tantalizing butter sauce.

From the Charcoal Broiler

SHISH KEBAB with Pilaff 6.25
The Near East's contribution to broiled cookery—mouth-watering morsels of selected spring lamb, marinated in wine and the herbs of the Near East—gently broiled over charcoal on skewers. The wild tribesmen of the Levant used to slaughter the sheep, skewer the fresh-cut chunks on their swords and broil it over the campfire. That's how the idea originated!

BROILED LAMB RIBS 4.75
Tempting morsels of lamb - more meat than you can shake a stick at - broiled to a turn with the matchless Canlis treatment of herbs and wine.

HAM STEAK, Charcoal Broiled . . . 4.75
A thick cut of Western Style Ham served with a piquant sweet sauce.

GROUND FILET BEEFSTEAK, Mushrooms 4.75
This epicurean patty of choice beef is ground from fine-grained meat, carefully selected from our choicest cuts . . . simply seasoned and charcoal broiled to your order. A delight to the senses!

HALF SPRING CHICKEN, Wild Rice . 4.00
Half a partially boned chicken, broiled and basted with wines and herbs, served on a bed of wild rice.

WHOLE MILK-FED BABY SQUAB . . 6.25
Fat, sassy little birds, fairly bursting with juice, brought to your table hot from the broiler where the chef has tenderly basted them with our secret blending of wines and herbs.

CHICKEN LIVERS EN BROCHETTE . 4.50

FRENCH LAMB CHOPS (Double Thick) 6.50
Short on glamour but long on appetite appeal. Broiled to your individual taste.

BROILED TIPS OF TENDERLOIN . . 6.25
Tender, lean slices of Tenderloin. Seasoned, skewered and broiled to perfection, en Brochette—period.

FILET MIGNON 6.75
No footnote needed to describe the Queen of red meats—except to say that this is the best procurable premium beef. Specify your wish —from raw-rare to well-done—and we'll time it to the minute. (Extra cuts on request.)

NEW YORK CUT STEAK 6.75
Traditionally a man's favorite cut. And we'll say it if the same things we said of the filet—no better beef can be bought and it's our job to broil it to the exact degree you wish. (Extra cuts on request.)

TOP SIRLOIN STEAK 6.50
Among many men of the meat packing industry this steak is their favorite. A husky piece of meat, long on juices and flavor.

MINUTE STEAK 6.00
For those who prefer a thinner steak, but demand the high quality of Canlis' standard, try this.

FILET STEAK SANDWICH 4.75

FRENCH PEPPERCORN STEAK . . . 7.50
A specially selected Filet or New York coated with freshly crushed peppercorns to preserve the natural juices and broiled as you like it —a taste thrill brought from Cafe Maxim of Paris.

DOUBLE NEW YORK CUT STEAK . . 14.00
For 2 Persons Served with Canlis Baked Potato.

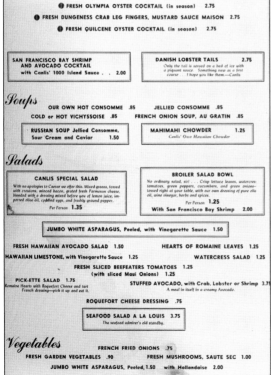

FRESH OLYMPIA OYSTER COCKTAIL (in season) 2.75

FRESH DUNGENESS CRAB LEG FINGERS, MUSTARD SAUCE MAISON 2.75

FRESH QUILCENE OYSTER COCKTAIL (in season) 2.75

SAN FRANCISCO BAY SHRIMP AND AVOCADO COCKTAIL
with Canlis' 1000 Island Sauce . . 2.00

DANISH LOBSTER TAILS 2.75
Only the tail is served on a bed of ice with a piquant sauce. Something new as a first course . I hope you like them.—Canlis

Soups

OUR OWN HOT CONSOMME .85
COLD or HOT VICHYSSOISE .85

JELLIED CONSOMME .85
FRENCH ONION SOUP, AU GRATIN .85

RUSSIAN SOUP Jellied Consomme, Sour Cream and Caviar 1.50

MAHIMAHI CHOWDER 1.25
Canlis' Own Hawaiian Chowder

Salads

CANLIS SPECIAL SALAD
With no apologies to Caesar we offer this. Mixed greens, tossed with croutons, minced bacon, grated fresh Parmesan cheese, blended with a dressing mixed before you of lemon juice, imported olive oil, coddled eggs, and freshly ground pepper.
Per Person 1.35

BROILER SALAD BOWL
No ordinary salad, sir! . . . Crisp lettuce leaves, watercress, tomatoes, green peppers, cucumbers, and green onions-tossed right at your table, with our own dressing of pure olive oil, wine vinegar, herbs and spices.
Per Person 1.25
With San Francisco Bay Shrimp 2.00

JUMBO WHITE ASPARAGUS, Peeled, with Vinegarette Sauce 1.50

FRESH HAWAIIAN AVOCADO SALAD 1.50
HAWAIIAN LIMESTONE, with Vinegarette Sauce 1.25

HEARTS OF ROMAINE LEAVES 1.25
WATERCRESS SALAD 1.25

FRESH SLICED BEEFEATERS TOMATOES 1.25
(with sliced Maui Onions) 1.25

PICK-ETTE SALAD 1.75
Romaine Hearts with Roquefort Cheese and tart French dressing—pick it up and eat it.

STUFFED AVOCADO, with Crab, Lobster or Shrimp 3.75
A meal in itself in a creamy Avocado.

ROQUEFORT CHEESE DRESSING .75

SEAFOOD SALAD A LA LOUIS 3.75
The seafood admirer's old standby.

Vegetables

FRENCH FRIED ONIONS .75
FRESH GARDEN VEGETABLES .90 FRESH MUSHROOMS, SAUTE SEC 1.00
JUMBO WHITE ASPARAGUS, Peeled, 1.50 with Hollandaise 2.00

CANLIS MENU (INSIDE). Canlis is famous for its special salad, which is made with mixed greens tossed with croutons, minced bacon, and grated fresh parmesan cheese, then blended with a dressing made from lemon juice, imported olive oil, coddled eggs, and freshly ground pepper. Rachel Lund, the private dining and promotions assistant for Canlis, said, "If we ever took that salad off of the menu, we would have a riot on our hands." (Author's collection.)

CASA VILLA. A touch of old Italy, the Casa Villa, was located at 1823 Eastlake Avenue in a peach stucco Italian villa. Dinners started with an appetizer plate of cold meats, olives, canapés, and peperoncini, then a vegetable salad with salsa condita (dressing), and next a native Milan minestrone soup. The entrée was spaghetti and ravioli, and for dessert there were petite fours and homemade spumoni. For $1, a person could eat as many entrées as they wished. (Author's collection.)

THE DOG HOUSE RESTAURANT. Bob Murray's Dog House opened in the 1930s and closed in 1994. "All Roads Lead to the Dog House" was one of the business's most famous mottos. Reporter John Hahn wrote that, "The Dog House was an epoch of Seattle history, a virtually non-stop, open-24-hours, run of food, booze, music, and fellowship." (Courtesy of the *Seattle Post-Intelligencer* Collection, MOHAI, No. 1986.5.11356.)

THE DOG HOUSE MENU. The motto of the Dog House was, "Where friends meet friends." The cocktail lounge had pictures of dogs on the walls, and in the rear of the café area, pictures of Seattle University basketball players hung on the walls. (Author's collection.)

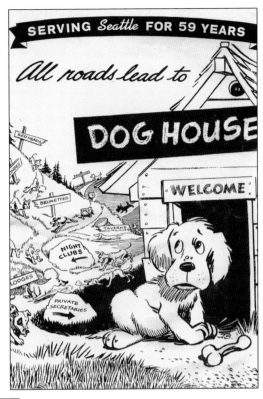

SERVING *Seattle* FOR 59 YEARS

All roads lead to

DOG HOUSE

WELCOME

our special **Sandwiches**	Bob's Special Hamburger	4.00
	(Diced Onions fried in, and French Fries)	
	Doghouse Super Hamburger	2.60
	DeLuxe Hamburger	3.00
	Cheeseburger	2.75
	DeLuxe Cheeseburger	3.75
	Hamburger Royal	3.75
	(Hamburger and Egg, Relish, Lettuce and Mayonnaise)	
	Chiliburger	3.75
	(Dog House Hamburger smothered with Chili)	
	The Bulldog	3.15
	(Choice Barbecued Beef)	
	The Pooch	3.15
	(Speaks for itself)	
	The Mutt	3.75
Our Hamburgers are all meat	*(Combination Ham and Hamburger)*	
	Side of French Fries or Hash Browns	2.25
	All Hamburgers served with Relish and Mayonnaise (Onions and Lettuce on request)	
CHICKEN AND CHIPS 3.95 **Chef's** **Suggestions** LOW CALORIE PLATE Hamburger Steak, Cottage Cheese 4.25	Combination Swiss Cheese and Corned Beef, Potato or Tossed Salad	5.25
	Corned Beef on Rye, Potato or Tossed Salad	5.25
	Beef Tenderloin Steak Sandwich	9.25
	Barbecued Ham on Bun with French Fries	4.60
	Club House Sandwich *(With Potato Salad)*	6.25
	Hot Turkey	6.25
	Hot Beef Sandwich	6.50
	French Dip	5.75
	(Tossed Salad, Roquefort Dressing, French Bread)	
	Monte Cristo Sandwich *(With Fruit Cup)*	6.25
	Reuben Sandwich *(With Potato Salad)*	6.25
Sandwiches	Salami, Bologna or Liverwurst (on Rye)	4.00
	Tuna Fish	2.90 Cold Ham 4.00
	Cold Beef	3.00 Tuna Fish and Tomato 4.10
	Egg Salad	2.75 Bacon and Tomato 4.10
	Chicken Salad	2.75 Fried Egg 2.75
	Swiss Cheese	2.75 Cold Turkey 4.25
	Ham and Egg	3.25 Grilled Ham and Cheese 4.25
	Grilled Cheese	2.75 Denver 4.50
	American Cheese	2.60 Lettuce and Tomato 3.25
	Minced Ham and Pickle	2.75 Peanut Butter and Jelly 3.00
	(Toasted or Grilled Sandwiches .05 extra, Sandwiches on Rye Bread .10 extra) (Our Sandwiches — Butter, Mayo, and Lettuce with Potato Chips)	
Beverages	Coca Cola .. Large .75 Small .40 Tea	.75
	Tab	.75 and .40 Milk .75 and 1.25
	Hot Chocolate	1.25 Milk Shake 2.50
	Orange Juice .. 1.00 and 1.50 Double Jersey Buttermilk .75	
	Grapefruit Juice	1.00 Ice Cream Soda 2.00
	Tomato Juice	1.00 Ice Cream Sundae 3.25
	Silex Brewed Coffee .75 Banana Split	5.25
	DeCaf	1.00
Soups	Cove Oyster Stew	5.25 Clam Chowder 3.00
	Soup of the Day	2.00 Small 1.50
	Small	1.25 *(Friday Only)*
	NOT RESPONSIBLE FOR LOST ARTICLES	**NO SERVICE IN BOO**

DOG HOUSE MENU (INSIDE). The Dog House was located at 2230 Seventh Avenue. The menu states, "Our hamburgers are all meat." The manager for most of the 60 years that the Dog House was open was Laurie Gulbransen (1913–2000). (Author's collection.)

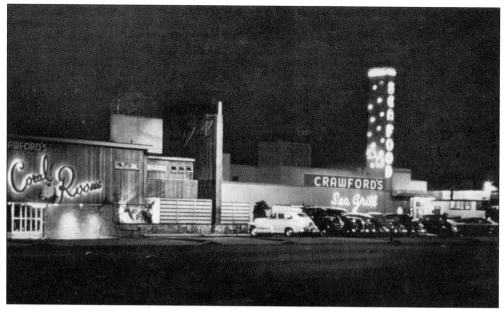

CRAWFORD'S SEA GRILL.
Crawford's Sea Grill specialized in seafood, steaks, chicken, and chops. Ivar Haglund, a Seattle character and restaurateur, was known as "King of the Waterfront" and later opened Ivar's Captain's Table on this same site, located below Queen Anne Hill. (Author's collection.)

CRAWFORD'S SEA GRILL MENU. An advertisement for Crawford's Sea Grill and Coral Room, printed in the 1958 city directory, publicized the restaurant's location on the shore of Puget Sound. The restaurant claimed to have "the finest seafood in the nation." Located at 333 Elliott Avenue West, the restaurant had seating for more than 100, and the glass-enclosed dining room had a view of Elliott Bay. (Author's collection.)

CRAWFORD'S SEA GRILL MENU (INSIDE).
Nick Zanides was the owner and operator of Crawford's Sea Grill. This menu, dated November 26, 1942, featured fresh, seasonal seafood and was subject to fishing conditions, such as abalone for the cost of $1.15 to $1.25 or lobster thermidor for $1.40. (Author's collection.)

CRAWFORD'S CORAL ROOM. Pictured here is a drink menu from Crawford's Coral Room. Both the cocktail lounge (on the second floor) and restaurant had huge windows to enjoy the view of trains roaring past and pleasure boats on Elliott Bay. Nick Zanides grew more than 500 rose bushes along the fence by the railroad tracks. (Courtesy of Ed and Colleen Weum.)

COCKTAILS and APPETIZERS

Martini	.50	Pink Lady	.65
Manhattan	.50	Scarlet O'Hara	.65
Gibson	.50	Between the Sheets	.75
Gimlet	.50	Sazerac	.70
Dubonnet	.50	Suisesse	.75
Perfect	.50	Trade Winds	.75
Rob Roy	.70	Shark's Tooth	.75
Old Fashioned	.50	Deep Sea	.75
Jack Rose	.55	El Presidente	.75
Daquiri50; Frozen	.60	Tahiti Club	1.00
Bacardi	.60	Champagne	1.00

BLENDED WHISKEY

Seagrams 7	.50	Park & Tilford Reserve	.50
Bellow's "Partner's Choice"	.50	Rock & Rye	.50
Corby's	.50	Four Roses	.55
Schenley's	.50		

STRAIGHT WHISKEY
Bottled Out of Bond

Walker's Deluxe	.60	Old Charter	.60
Jim Beam	.60	Ancient Age	.60
Early Times	.60	Barclay's Rye	.60

CANADIAN WHISKEY

Canadian Club	.60	Harwood's	.60
Seagram's V. O.	.60	McNaughton's	.60

STRAIGHT WHISKEY
Bottled in Bond

I. W. Harper	.70	Old Forester	.70
Kentucky Tavern	.70	Old Crow	.70
Old Grandad	.70	Old Overholt (Rye)	.70
Old Taylor	.70		

SCOTCH WHISKEY

Ballantine's	.65	White Horse	.65
Black & White	.65	Haig & Haig 5 Star	.65
Dewar's White Label	.65	Haig & Haig Pinch	.75
King William IV	.65	Hudson's Bay 1670	.75
Hudson's Bay "Best Procurable"	.65	Johnny Walker's Black Label	.75
Vat 69	.65	Dewar's Victoria Vat	.75
Johnny Walker's Red Label	.65		

SOURS and "PICKUPS"

Whiskey Sour	.50	Coral Room Sour	.65
Gin Sour	.50	Gin Buck	.50
Brandy Sour	.50	Gin Rickey	.50
Scotch	.70	Circus Rickey	.55
Ward 8	.60	Mamie Taylor	.65

COLLINS

Tom Collins	.50	Brandy Collins	.50
John Collins	.50	Vodka Collins	.50
Rum Collins	.50	Crawford's Collins	.65

FIZZES

Gin Fizz	.50	New Orleans Fizz	.65
Silver Fizz	.65	Ramos Fizz	.65
Golden Fizz	.65	Sloe Gin Fizz	.50
Royal Fizz	.65	Coral Room Fizz	.65

FLIPS and PUNCHES

Brandy Flip	.65	Whiskey Flip	.65
Sherry Flip	.50	Egg Nog	.65
Port Flip	.50		

HOT DRINKS

Hot Buttered Rum	.65	Tom & Jerry (in season)	.65
Hot Toddy (Rum, Brandy, Whiskey)	.60	Whiz Bang	.75

TALL DRINKS

Moscow Mule	.60	Zombie	1.25
Cuba Libre	.50	Mint Julep (in Season)	1.00
Scotch Cooler	.65	Port o'San Juan	.85
French 75	1.00	Bali Bali	.85
Singapore Sling	.75	South Sea Dipper	1.00
Planter's Punch	.75		

LIQUERS and AFTER DINNER COCKTAILS

Alexander Gin	.65	Drambuie	.75
Alexander Brandy	.65	King Alfonse	.50
Side Car	.65	Pousse Cafe	1.00
Stinger	.65	Creme de Menthe Frappe	.55
After Dinner Cocktail	.75	Anisette	.50
Forbidden Fruit	.75	Cointreau	.60
Cognac (Martell-Hennessey)	.75	Grand Mariner	.60
Brandy (Christian Bros.)	.50	Orange Curacoa	.50
D. O. M. Benedictine	.75	Narasqui	.50
B & B	.75	Kummel	.50
Cherry Herring	.75	Peppermint	.50
Chartreuse, Yellow	.75	Apricot and Cherry	.50
Chartreuse, Green	.85	Blackberry and Peach	.50

Eastern Beer and Ale30	**Western Beer and Ale**25	**Tuborg Beer (Imported)**55

THE GOLDEN LION. The Golden Lion restaurant was located in the Olympic Western Hotel at Fifth Avenue and University Street. It had a romantic atmosphere of the British Colonies and featured waiters in turbans serving flaming entrees. Retail space would later replace the Golden Lion. (Courtesy of Mary Patterson.)

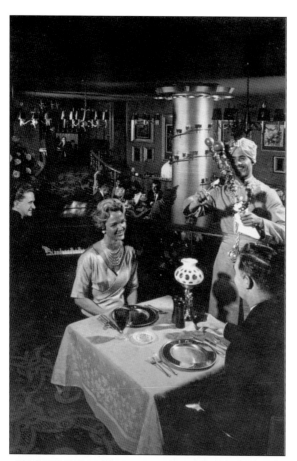

THE EL GAUCHO. Above is an ektachrome postcard by Clifford B. Ellis of the El Gaucho restaurant located at Seventh Avenue and Olive Street. It was internationally acclaimed for fine steaks and distinguished decor. Shown is the Mink Booth, where important people from world affairs, entertainment, and sports met to dine. The Gold Room was ornately complemented with famous El Gaucho $4,000 gold-plated flatware for private parties. (Author's collection.)

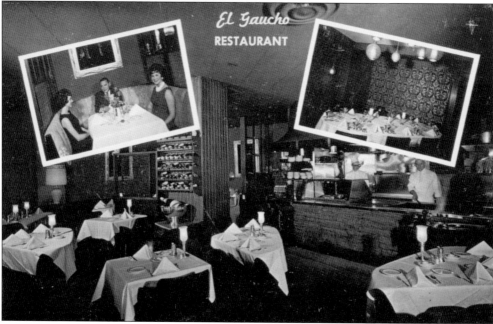

THE EL GAUCHO BAR. This photograph, taken on St. Patrick's Day, March 17, 1959, shows an unidentified bartender with customers at the bar wearing their shamrock hats. The usual decor of El Gaucho was of cowboys of the Pampas with dark-haired waitresses in fiesta skirts wearing off-the-shoulder blouses waiting on tables. The El Gaucho restaurant, which opened in 1954, is well known for its 28-day, dry-aged, certified, Angus beef prime; Caesar salads tossed tableside; and flaming shish kebabs called "en espanada flamente." Founder Paul Mackay recalls that, "The first time I walked into the Gaucho, the ambiance hit me. It was the most stunning place I had ever seen in my life, and I thought that sometime I would like to work there." El Gaucho is still open, and El Gaucho Bellevue is the fourth location to open in the fall of 2008. The restaurants are also known for a nightly piano bar and the famously nostalgic, 1950s "retro-swank" atmosphere. (Courtesy of the Robert H. Miller Collection, MOHAI, No. 2002.46.15.)

GEORGIAN ROOM MENU. On the cover is an image of women eating in the Georgian Room at the Olympic Hotel in Seattle in 1948. Multiple lunch and dinner menus with various covers were used during the 1950s. On the back of this menu, Tom Gildersleve is listed as the general manager in Seattle. The Georgian Room was the Olympic Hotel's main dining room. (Author's collection.)

GEORGIAN ROOM DINNER MENU (INSIDE). The Georgian Room dinner on Monday, April 4, 1949, featured hors d'oeuvres, soup, and an entrée, including dessert, for a total price, depending on the entrée chosen, ranging from $2.95 to $4.35. Planked Chateaubriand for two cost a mere $10. Charles Eusebe was the chef de cuisine, and Harold Hallstrom was the maitre d'hotel. (Author's collection.)

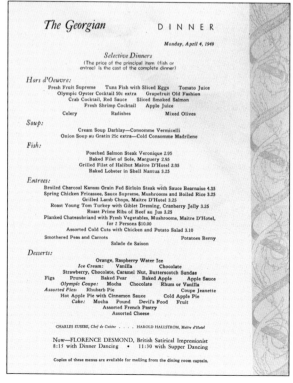

GREEN APPLE PIE SHOP POSTCARD. Located at 521 Pike Street, this restaurant sold sandwiches as well as a famous green apple pie for 10¢ a slice. Other pies were fresh huckleberry, apricot, cherry, pineapple cream, hot mince, and pumpkin, which also cost only 10¢ per slice. (Courtesy of John Cooper.)

GREEN APPLE PIE SHOP. During World War II and in the postwar years, the Green Apple Pie Shop was a popular eatery in downtown Seattle. It was recommended by the Western Motor Association. (Courtesy of the Robert H. Miller Collection, MOHAI, No. 2002.46.22.)

GREEN APPLE PIE SHOP. This photograph is of the interior of the Green Apple Pie Shop showing the streamlined spotless café and counter. (Courtesy Robert H. Miller Collection, MOHAI 2002.46.23.)

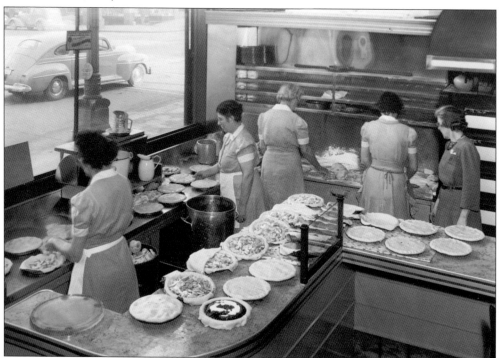

GREEN APPLE PIE SHOP KITCHEN. Photographed in 1945 by Webster and Stevens, these women were making pies at the Green Apple Pie restaurant. (Courtesy PEMCO Webster and Stevens Collection, MOHAI 1983.10.15338.1.)

HYATT HOUSE. This 1976 postcard shows the Seattle Hyatt House, which was located at the Seattle-Tacoma International Airport at 17001 Pacific Highway South. An extravagant weekend package for two at this resort-type motel cost $29.50. The restaurant was cosmopolitan and featured roast Long Island duck and chicken a la kiev. (Author's collection.)

THE IRON HORSE RESTAURANT. Known as Seattle's most unique dining spot, this restaurant delivered meals to the table by large-scale model trains. The Iron Horse Restaurant was located in the historic Pioneer Square District. Children were welcome, while adults were tolerated if sufficiently immature. (Courtesy of Robin Anderson.)

ITALIAN VILLAGE CAFÉ. This 1936 photograph shows the Italian Village Café and the surrounding businesses located in the 1400 block of Fifth Avenue. (Courtesy of the *Seattle Post-Intelligencer* Collection, MOHAI, No. 1986.5.11368.1)

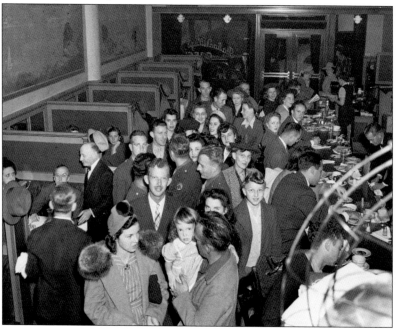

ITALIAN VILLAGE CAFÉ CROWD. A crowd gathers inside the Italian Village Café in Seattle on September 29, 1942. The café was a popular downtown eatery. (Courtesy of the *Seattle Post-Intelligencer* Collection, MOHAI, No. 1986.5.11369.)

ITALIAN VILLAGE RESTAURANT MENU. The Italian Village Café was located at 1413 Fifth Avenue. This menu was dated Thursday, September 6, 1951. (Author's collection.)

Italian Village

1413 Fifth Avenue
Seattle, Washington

NOT RESPONSIBLE FOR LOSS
OF GOODS NOT CHECKED . . .

80c Plate Lunch 80c	$1.00 Merchant's Lunch $1.00
(Served from 10:30 a. m. to 3 p. m.)	(Served from 10:30 a. m. to 3 p. m.)
	Minestrone
Chopped Veal Steak with Ravioli	Chopped Veal Steak with Ravioli
Fried Salmon, Drawn Butter	Fried Salmon, Drawn Butter
Boiled Corned Beef and Cabbage	Boiled Corned Beef and Cabbage
Veal Kidneys Sauté with Spaghetti	Veal Kidneys Sauté with Spaghetti
Plain Omelette with Spaghetti	Plain Omelette with Spaghetti
Cottage Cheese, Sliced Tomatoes	Cottage Cheese, Sliced Tomatoes
Spaghetti and Meat Balls	Spaghetti and Meat Balls
Spaghetti or Ravioli	Spaghetti or Ravioli
Coffee or Milk	Lunch Salad
	Ice Cream or Sherbet Coffee or Milk

DINNER $1.75

Minestrone or Chicken Broth
Spaghetti or Ravioli

ENTREES (Choice of One)

Baked Stuffed Spring Chicken
Fried Halibut, Drawn Butter
Antipasto Salad, Village Special
Denver Omelette
Cold Meats with Potato Salad
Breaded Pork Chops, Tomato Sauce
Small Beef Tenderloin with Mushrooms 1.85
Spaghetti with Meat Balls

Potatoes Vegetable
Cantaloupe or Choice of Desserts Coffee, Tea or Milk

DINNER $2.30

Fruit, Crab or Shrimp Cocktail Appetizer
Minestrone or Chicken Broth
Spaghetti or Ravioli

ENTREES (Choice of One)

Roast Stuffed Turkey with Cranberry Sauce
Lamb Chops, Fried Tomatoes
Breaded Veal Cutlets, Tomato Sauce
Pork Tenderloin with Mushrooms
Fried Spring Chicken, Italian Style
Fried Prawns in Butter, Tartar Sauce
Fried Willapa Oysters, Drawn Butter
Filet Mignon with Mushrooms 2.75
Choice Rib Steak al Buro 2.75

Cantaloupe, Ice Cream, Pie or Sherbet Coffee, Tea, Buttermilk or Milk

NO SERVICE LESS THAN 35c Thursday, Sept. 6, 1951

SOUPS
Clam Chowder 30 Vegetable 20 Tomato 30 Chicken Gumbo, Creole 30
Chicken Broth 30 Minestrone 30 Genuine Turtle 35 Cream of Mushroom 35

TO-DAY'S SPECIALS
Corned Beef and Cabbage with Spaghetti	1.25
Small Steak with Mushrooms and Spaghetti	1.70
Chopped Veal Steak, Mushrooms, Spaghetti	1.15
Hot Beef, Veal or Pork Sandwich with Spaghetti and Potatoes	1.05
Hot Turkey Sandwich with Spaghetti and Potatoes	1.15
Breaded Veal Cutlets, Tomato Sauce and Spaghetti	1.30
Boiled Chicken, Italian Style	1.40
Spaghetti with Anchovies	1.55
Spaghetti with Meat Balls 1.15; Half Order	.90
Italian Pork Sausage Sauté with Mushrooms and Spaghetti	1.85
SPAGHETTI OR RAVIOLI 95; Half Order	.75
SIDE OF SPAGHETTI SAUCE 30 SIDE OF PARMIGIANO CHEESE 30	
NOTE: Side Order of Spaghetti or Ravioli served with Entree Only	40

ROASTS
Roast Stuffed Turkey, Spaghetti, Cranberry Sauce	1.65
Roast Chicken with Spaghetti	1.65
Roast Veal with Celery Dressing	1.45
Roast Pork with Apple Sauce and Dressing	1.50
Roast Sirloin of Beef with Spaghetti	1.50

FISH
Prawns Fried in Butter, Cole Slaw	1.60
Fried Salmon Steak, Drawn Butter, Cole Slaw	1.15
Fried Halibut Steak, French Fried Potatoes	1.10

ITALIAN VILLAGE CAFÉ MENU (INSIDE). On this page of the menu, one could order a combination dinner for $1.75 or $2.30. On the back of the menu was written: "De Luxe Dinner $3.50—A genuine 8 course Italian dinner with tenderloin steak or spring chicken." (Author's collection.)

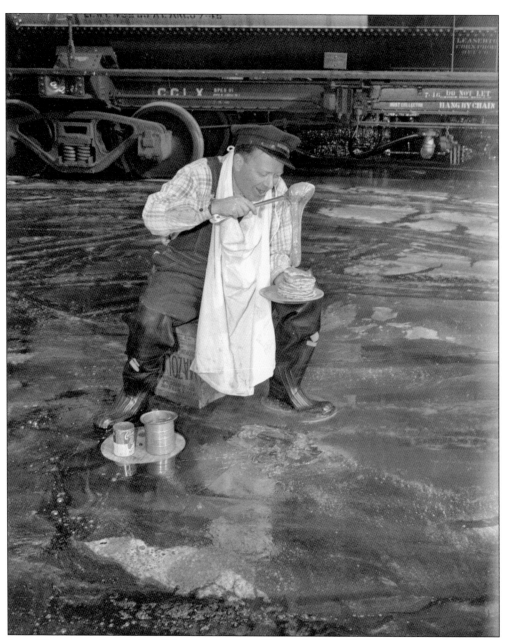

IVAR HAGLUND. An Alaskan Way messy syrup spill provided Ivar Haglund an occasion to create a "gooey" scene. In Seattle in 1947, while a tanker car was being loaded, a coupling broke, and out poured thousands of gallons of sticky corn syrup. The spill occurred at Alaskan Way and Columbia Street. The Corn Products Refining Company used the glucose for candy and syrups. The congealing mess had to be heated with steam so the clean-up crew could scoop it up with coal shovels and dump it into barrels. Haglund, being a prankster, threw on some hip boots, grabbed some pancakes from his restaurant, and trotted across the road to pose for photographer John M "Hack" Miller. As the reporter noted, "What he puts on his customers' hot cakes from now on is anybody's guess." (Courtesy of the *Seattle Post-Intelligencer* Collection, MOHAI, No. 1986.5.27280.)

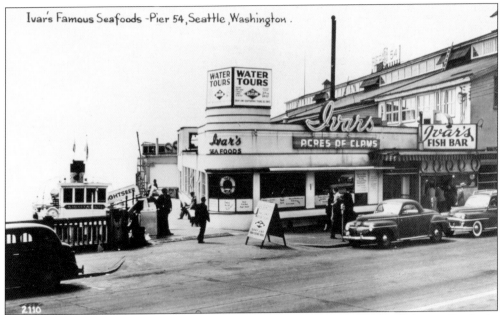

IVAR'S ACRES OF CLAMS RESTAURANT. Above is a real-photo postcard of Ivar's Famous Seafoods, located on Pier 54 in Seattle. One slogan was, "What with the city's leading professional men, artists, writers, world travelers, and visiting VIP'S always dropping into the place, it has become the spot where clams and culture meet." (Courtesy of John Cooper.)

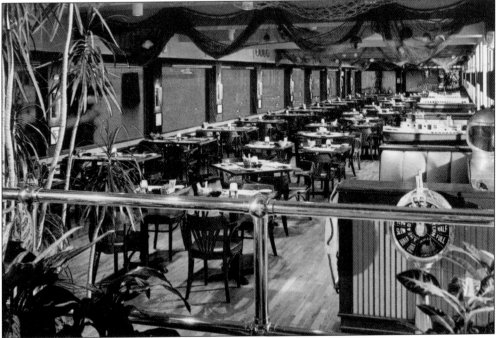

IVAR'S DINING. Overlooking the water, the informal restaurant has been a Seattle waterfront tradition since 1938. Owner Ivar Haglund decorated his restaurant with aquatic-type gear, funny signs, and nets with glass balls throughout the beamed ceiling. There is a sit-down restaurant inside and a fish bar on the outside where one can order seafood to go. (Courtesy of John Cooper.)

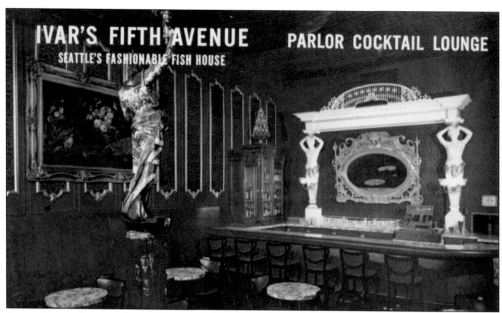

IVAR'S FIFTH AVENUE FISH HOUSE. Above is a postcard of Ivar Haglund's upscale Fish House. A quotation from the restaurant's Web site reads, "Have you lost yourself lately in the gastronomical delights of Ivar's Acres of Clams or Ivar's Fifth Avenue?" (Courtesy of John Cooper.)

We Aim to Please — SEAFOOD DINNERS

APPETIZERS TO SELECT FROM — Smoked King Salmon • Sour Cream Marinated Herring • Tomato Juice, Crab Meat, Shrimp or Oyster Cocktail • Steamed Clams • Avocado Cocktail • Sauteed Cold Pickled Smelts

CHOICE OF SOUPS — Clam Chowder • Onion Soup • Clam Nectar • Vichyssoise (hot or cold)

SALADS and DRESSINGS — Romaine • Head Lettuce • Celery and Olives or Cole Slaw
The 5th Ave. Special Dressing, Thousand Island, French, Roquefort, or Oil and Vinegar

CHOICE OF ENTREE DETERMINES THE PRICE OF YOUR DINNER

GENUINE FINNAN HADDIE $2.95

SHORE GRILL PLATE $3.75
(French Fried Crab Legs, Oysters, Prawns, Scallops and Onion Rings.)

SALMON
POACHED KING SALMON STEAK $3.65
BAKED PACIFIC SALMON, with Ivar's Dressing ... $3.25
GRILLED KING SALMON STEAK $3.35
CHARBROILED FILET OF KING SALMON ... $3.65

ALASKA SHRIMPS
SHRIMPS A LA NEWBURG $3.65
(Served with Rice)

OYSTERS
PAN FRIED QUILCENE OYSTERS $2.85
(Served in Iron Skillet)
QUILCENE PEPPER PAN ROAST $3.45

PUGET SOUND SOLE
SOLE RUBY $3.15
(Poached sole, covered with crab meat. Bernaise Sauce, asparagus, crab legs.)
SOLE BONNE FEMME $3.25
(Sole, mushrooms, and fine chopped onions, steamed in White Wine, served with sauce Vin-Blanc, slightly glazed.)
GRILLED FILET OF SOLE $2.95

SCALLOPS
FRENCH FRIED DEEP SEA SCALLOPS $3.35
BUTTER FRIED DEEP SEA SCALLOPS $3.45
CHARBROILED SCALLOPS $3.50
(With Mushrooms en Brochette)

DUNGENESS CRAB
BUTTER FRIED CRAB LEGS $3.55
FRENCH FRIED CRAB LEGS $3.45
CRAB A LA NEWBURG $3.65
(Served with Rice)

HALIBUT
POACHED FILET OF HALIBUT, Fermiere Sauce ... $3.45
GRILLED HALIBUT STEAK $3.45

PRAWNS
CHARBROILED PRAWNS, En Brochette $3.60
FRENCH FRIED PRAWNS ON TOAST $3.45

IVAR' FAMOUS
BABY PACIFIC FRIED CLAMS
A la Carte $1.75

IVAR'S GRILLED RED SNAPPER $2.95

UPON YOUR REQUEST ANY ENTREE ON THE DINNERS ARE AVAILABLE A LA CARTE.

THE CHOICE OF—Hashed-Browned, Boiled, Baked and French Fried Potatoes, or if desired, a Fresh Vegetable Du Jour, are available to accompany your choice of entree.

DESSERTS or CHEESE
ICE CREAM • SHERBET • ASSORTED PIES • AMERICAN, SWISS or DANISH BLUE CHEESE
COFFEE or TEA

IVAR'S FIFTH AVENUE SEAFOODS MENU. Don's Seafoods, which opened in 1898, was the oldest seafood restaurant in Seattle. The Fifth Avenue Whaling and Trading Corporation owned Ivar's Fifth Avenue Seafoods and took over one of Don's Seafoods' locations. Ivar Haglund also owned the Ivar's Acres of Clams restaurant. (Courtesy of Nancy Leson, *Seattle Times*.)

IVAR'S PIER 54 MENU (INSIDE). Pictured here is an early menu from Ivar's Pier 54, showing why one's elders complain about today's high prices. The restaurant also had a menu shaped like a clam. An order of fish and chips cost 85¢ a la carte or a full course dinner cost $1.35. (Author's collection.)

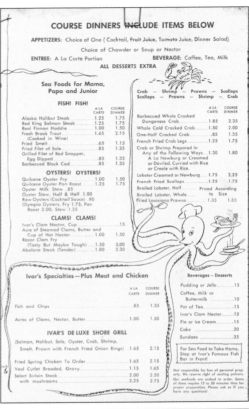

COURSE DINNERS INCLUDE ITEMS BELOW

APPETIZERS: Choice of One (Cocktail, Fruit Juice, Tomato Juice, Dinner Salad)

Choice of Chowder or Soup or Nectar

ENTREE: A La Carte Portion **BEVERAGE:** Coffee, Tea, Milk

ALL DESSERTS EXTRA

Sea Foods for Mama, Papa and Junior

FISH! FISH!

	A LA CARTE	COURSE DINNER
Alaska Halibut Steak	1.25	1.75
Red King Salmon Steak	1.25	1.75
Real Finnan Haddie	1.00	1.50
Fresh Brook Trout (Cooked in Wine)	1.65	2.15
Fried Smelt	.65	1.15
Fried Filet of Sole	.85	1.35
Grilled Filet of Red Snapper, Egg Dipped	.85	1.35
Barbecued Black Cod	.85	1.35

OYSTERS! OYSTERS!

	A LA CARTE	COURSE DINNER
Quilcene Oyster Fry	1.00	1.50
Quilcene Oyster Pan Roast	1.25	1.75
Oyster Milk Stew	.85	
Oyster Stew, Half & Half	1.00	
Raw Oysters (Cocktail Sauce)	.90	
Olympia Oysters, Fry 1.75; Pan Roast 2.00; Stew 1.25		

CLAMS! CLAMS!

	A LA CARTE	COURSE DINNER
Ivar's Clam Nectar, Cup	.15	
Acre of Steamed Clams, Butter and Cup of Hot Nectar	1.00	1.50
Razor Clam Fry (Tasty But Maybe Tough)	1.50	2.00
Abalone Steak (Tender)	1.80	2.30

Crab — Shrimp — Prawns — Scallops
Scallops — Prawns — Shrimp — Crab

	A LA CARTE	COURSE DINNER
Barbecued Whole Cracked Dungeness Crab	1.85	2.35
Whole Cold Cracked Crab	1.50	2.00
One-Half Cracked Crab	.85	1.35
French Fried Crab Legs	1.25	1.75
Crab or Shrimp Prepared In Any of the Following Ways	1.30	1.80
A La Newburg or Creamed or Deviled, Curried with Rice or Creole with Rice.		
Lobster Creamed or Newburg	1.75	2.25
French Fried Scallops	1.25	1.75
Broiled Lobster, Half	Priced According	
Broiled Lobster, Whole	to Size	
Fried Louisiana Prawns	1.35	1.85

Ivar's Specialties — Plus Meat and Chicken

	A LA CARTE	COURSE DINNER
Fish and Chips	.85	1.35
Acres of Clams, Nectar, Butter	1.00	1.50

IVAR'S DE LUXE SHORE GRILL

(Salmon, Halibut, Sole, Oyster, Crab, Shrimp, Smelt, Prawn with French Fried Onion Rings)	1.65	2.15
Fried Spring Chicken To Order	1.65	2.15
Veal Cutlet Breaded, Gravy	1.15	1.65
Select Sirloin Steak	2.00	2.50
with mushrooms	2.25	2.75

Beverages — Desserts

Pudding or Jello	.15
Coffee, Milk or Buttermilk	.10
Pot of Tea	.15
Ivar's Clam Nectar	.15
Pie or Ice Cream	.15
Cake	.20
Sundaes	.25

For Sea Food to Take Home, Stop at Ivar's Famous Fish Bar in Front!

Not responsible for loss of personal property. We reserve right of seating patrons. Our seafoods are cooked to order. Some of them require 15 to 20 minutes time for proper preparation. Please ask us if you have any questions!

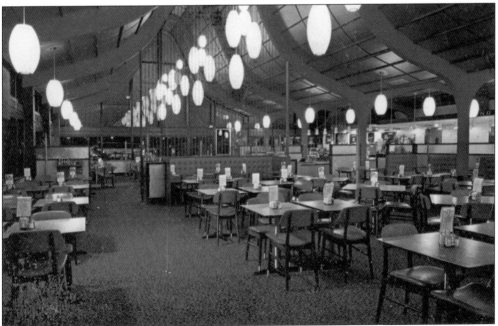

MANNING'S CAFÉ. This postcard shows Manning's in Ballard. It was a cafeteria and buffet that served family-style food prepared by all-women cooks. Manning's was located at 5505 Fifteenth Avenue NW in Seattle. (Author's collection.)

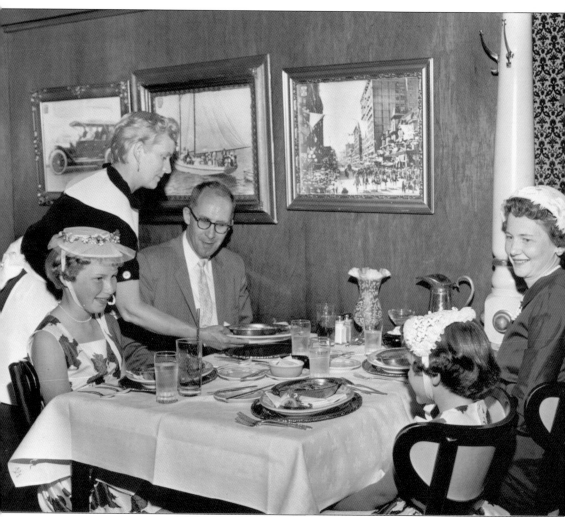

KING OSCAR'S RESTAURANT. King Oscar's Smorgasbord was located at 4312 Aurora Avenue North. This photograph was filed by the *Seattle Post-Intelligencer* on November 22, 1959, but the family looks to be dressed in Easter clothes. This Swedish restaurant had several famous guests, including the crown prince of Denmark and Wendell Wilkie, who all signed the guest book. Bill Jensen was the general proprietor. Not only was the restaurant known for its smorgasbord, but customers loved the Swedish pancakes. The Swedish pancakes were served king's style, filled with a rich cream sauce, chicken, and mushrooms, all served from a chafing dish at the table—Scandinavian style. Upstairs was a cocktail lounge called the Fjord Room, which featured Scandinavian decoration. A drink called "the Voyager" was served in a bowl for two with little Viking ships floating in it. The restaurant was truly a warm, inviting, Scandinavian mountain chalet with dark wood beams and vibrant red, yellow, and blue colors throughout the restaurant. (Courtesy of the *Seattle Post-Intelligencer* Collection, MOHAI, 1986.5.11372.2.)

MAISON BLANC. Charles Joseph Ernest Blanc opened Maison Blanc on January 12, 1916, during Prohibition. Blanc was a founder of the Chef's de Cuisine organization. His restaurant decor featured antiques and various forms of art, including marble statues, bronzes, ceramics, and oil paintings. (Author's collection.)

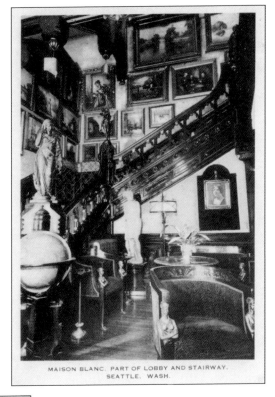

MAISON BLANC. PART OF LOBBY AND STAIRWAY. SEATTLE. WASH.

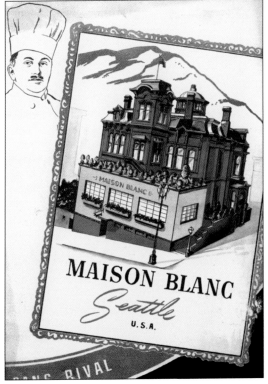

MAISON BLANC MENU. The menu cover is illustrated with a drawing of the historical mansion that housed this restaurant and the face of owner, Charles J. E. Blanc. The cover is detailed in gold, with Mount Rainier hovering over the Maison Blanc. The cover also claimed the Maison Blanc was "sans rival." The Rathskeller bar was below Maison Blanc at sidewalk level. The inside of the menu had stories and statements from the owner. (Author's collection.)

95

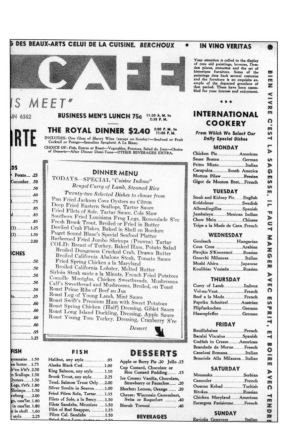

Menu text (as visible):

G DES BEAUX-ARTS CELUI DE LA CUISINE. BERCHOUX • IN VINO VERITAS

CAFE

IS MEET"

Your attention is called to the display of rare old paintings, bronzes, Dresden pieces, statuettes and the set of historique furniture. Some of the paintings date back several centuries and the furniture is an exquisite example of the departed grandeur of that period. These have been assembled for your interest and enjoyment.

IN 6562 BUSINESS MEN'S LUNCH 75c 11:30 A.M. to 2:30 P.M.

RTE

THE ROYAL DINNER $2.40 2:00 P.M. to 11:00 P.M.

INCLUDES: One Glass of Sherry Wine (except on Sunday)—Seafood or Fruit Cocktail or Potage—Semolina Spaghetti A La Blanc.

CHOICE OF: Fish, Entree or Roast—Vegetables, Potatoes, Salad or Jour—Choice of Deserts—After Dinner Demi-Tasse—OTHER BEVERAGES EXTRA.

INTERNATIONAL COOKERY

From Which We Select Our Daily Special Dishes

MONDAY
Chicken Pie American
Sauce Braten German
Fritto Misto Italian
Carapulca South America
Mutton Pilaw Persian
Gigot de Mouton Bret...French

TUESDAY
Steak and Kidney Pie ...English
Koldolmar Swedish
Albondiguillas Spanish
Jambalaya Mexican Indian
Chow Mein Chinese
Tripe a la Mode de Caen .French

WEDNESDAY
Goulasch Hungarian
Cous Cous Arabian
Pirojkis S'Kouretsoi ...Russian
Gnocchi Milanesa Italian
Mushi Abira Japanese
Koulibiac Vesiada Russian

THURSDAY
Curry of Lamb Indoux
Vol-au-Vent French
Beef a la Mode French
Paprika Schnitzel ... Austrian
Flipfankuchen German
Hasenpfeffer German

FRIDAY
Bouillabaisse French
Bacalai Vizcaina Spanish
Codfish in Cream American
Brandade de Morue ... French
Caneloni Romana Italian
Brasciole Alla Milanesa .Italian

SATURDAY
Moussaka Serbian
Cassoulet French
Ouseun Kebad Turkish
Bitokea Russian
Chicken Maryland ... American
Escargots Parisienne ..French

SUNDAY
Raviolis Genevese Italian

DINNER MENU
TODAYS—SPECIAL "Cuisine Indoue"
Bengal Curry of Lamb, Steamed Rice
Twenty-two Selected Dishes to choose from
Pan Fried Jackson Cove Oysters au Citron
Deep Fried Eastern Scallops, Tartar Sauce
Fried Filets of Sole, Tartar Sauce, Cole Slaw
Southern Fried Louisiana Frog Legs, Remoulade S'ce
Fresh Brook Trout, Broiled or Fried in Butter
Deviled Crab Flakes, Baked in Shell en Bordure
Puget Sound Blanc's Special Seafood Platter
Barbecued Fried Jumbo Shrimps (Prawns) Tartar
COLD: Breast of Turkey, Baked Ham, Potato Salad
Broiled Dungeness Cracked Crab, Drawn Butter
Broiled California Abalone Steak, Tomato Sauce
Fried Spring Chicken a la Maryland
Broiled California Lobster, Melted Butter
Sirloin Steak saute a la Minute, French Fried Potatoes
Coquille Montglas, Chicken Sweetbreads, Mushrooms
Calf's Sweetbread and Mushrooms, Broiled, on Toast
Roast Prime Ribs of Beef au Jus
Roast Leg of Young Lamb, Mint Sauce
Roast Swift's Premium Ham with Sweet Potatoes
Roast Spring Chicken (Half) Dressing, Giblet Sauce
Roast Long Island Duckling, Dressing, Apple Sauce
Roast Young Tom Turkey, Dressing, Cranberry S'ce
Dessert

FISH
Halibut, any style95
Alaska Black Cod 1.00
King Salmon, any style .. 1.10
Brook Trout, any style .. 2.25
Tend. Salmon Trout Only ..2.00
Silver Smelts in Season ..1.00
Fried Filets Sole, Tartar ..1.35
Filets of Sole, a la Bercy ..1.50
Filets Sandabs, Meuniere ..1.50
Filet of Red Snapper1.35
Filets Cal. Sandabs1.50

DESSERTS
Apple or Berry Pie .20 Jello .15
Cup Custard, Chocolate or Rice Custard Pudding15
Ice Cream: Vanilla, Chocolate, Strawberry or Panache ...20
Sherbet: Lemon, Orange20
Cheese: Wisconsin Camembert, Swiss or Roquefort40
Biscuit Tortoni40

BEVERAGES

(vertical right margin:) BIEN VIVRE C'EST LA SAGESSE, IL FAUT MANGER AVEC ESPRIT, ET BOIRE AVEC TENDRE

MAISON BLANC MENU (INSIDE).
The menu featured gourmet food from around the world. Maison Blanc had many slogans, including "An Aristocratic Meal at a Democratic Price" and "Where Epicureans Meet." (Author's collection.)

NEW WASHINGTON HOTEL. This c. 1927 photograph was taken of Babe Ruth (1895–1948) when he was surrounded by young children and being fed a turkey leg. Ruth was sitting on the stairs at the New Washington Hotel. The New Washington Hotel manager's son, Harold Warner, is the fair-haired boy standing on the stairs just above Ruth. (Courtesy of MOHAI, No. 1986.5G.2634.)

MOULTRAY'S FOUR WINDS MENU. On the lower end of Lake Union, at 900 Westlake Avenue North, sat the old *City of Everett*, a ferry that Chris and Bill Moultray had overhauled into a pirate ship restaurant. The pirate theme followed through to the menu pictured here, as it did in the decor of the restaurant and the pirate costumes of the waitresses. (Author's collection.)

CHARCOAL BROILER

All Steaks, Seafoods and Orders from the Pit of the Four Winds Served with Tossed Green Salad
Baked One-Pound Potato with our Special Trimmings and Toasted Onion-Buttered French Bread

FROM THE PIT OF THE FOUR WINDS

PRIME RIBS OF BEEF with Natural Juice — LARGE CUT	4.25
— EXTRA LARGE CUT	4.75
HICKORY BARBECUED SPARERIBS	3.50
SUPRÊMES de CHAPON SOUS CLOCHE	3.75
Broiled Breasts of Capon delicately flavored with a wine sauce and served to your table under glass	
WHOLE BROILED CORNISH GAME HEN . . . (Le Petite Poussin)	4.50
Charcoal-broiled, steeped in wine, and served with wild rice en casserole. "For those who find romance in the search for fine food . . . to those gourmets who explore the seven seas for something different . . . something new under the sun . . . we recommend this dish . . . truly the pièce de resistance for fine dining."	
BEEF TENDERLOIN EN BROCHETTE	4.50
Mouth-watering morsels of beef tenderloin, gently broiled over charcoal on skewers with fresh mushrooms and tomatoes	
FOUR WINDS DOUBLE LAMB CHOP a la vert pre	3.75
Boned Loin Chops, skewered, charcoal-broiled and served with mint sauce	
BROILED HAM STEAK, Currant Wine Sauce	2.90

STEAKS . . . Grain Fed, Properly Aged Steer Beef — The Finest Obtainable

NEW YORK CUT	5.00
FILET MIGNON Rum Sauteed Mushrooms	5.00
FOUR WINDS CLUB SIRLOIN	4.50
CHOPPED SIRLOIN STEAK Mushroom Saute	3.50
BROILED CALF'S LIVER STEAK French Fried Onion Rings	3.00

SEAFOODS

CHARCOAL-BROILED LOUISIANA SHRIMP, BORDELAIS SAUCE	3.25
FROGS' LEGS DEMI-BORDELAIS	3.75
Two pair of Louisiana frog legs deep fried and served with an unusual sauce	
FRENCH FRIED CRAB LEGS, CAJUN SAUCE	2.95
LES HUITRES EN COQUILLE a la ROCKEFELLER	3.50
(Oysters a la Rockefeller)	
BROILED FILLET OF KING SALMON, Prepared Orcas Island Style	3.00
No ordinary fish . . . fresh from Puget Sound . . . thick and juicy	
WHOLE BROILED LOBSTER	4.50
Steeped in Wine, Served with a hot butter sauce that will pique your appetite	
DEVILED CRAB AU GRATIN	3.00

MOULTRAY'S FOUR WINDS MENU (INSIDE). The restaurant offered frogs' legs demi-bordelais for $3.75, Caesar salad a la moultray for $1.50 (prepared at the table), charcoal-broiled steaks and seafood, and whole, broiled lobster for $4.50. A Cannon Ball drink (advertised as a drink "for a real he-man, a drink that will shiver your timbers") was offered for 97¢. (Author's collection.)

NIFTY RESTAURANT. The Nifty Restaurant was located at 1102 Southwest Spokane Street by Harbor Island in Seattle. It was open for breakfast, lunch, and dinner. (Courtesy of the Southwest Seattle Historical Society.)

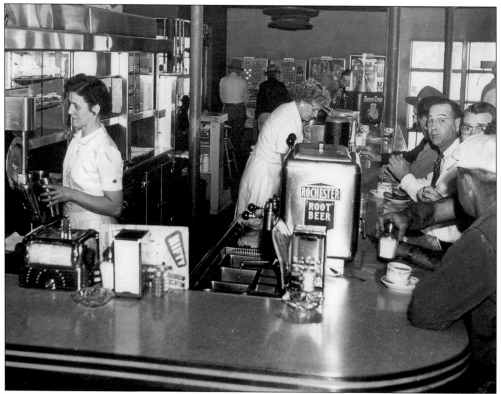

NIFTY RESTAURANT (INSIDE). Author Robin Shannon's father, Roger Shannon, the superintendent of the Texaco plant on Harbor Island, ate here a few times; but even he said this photograph was before his time. (Courtesy of the Southwest Seattle Historical Society.)

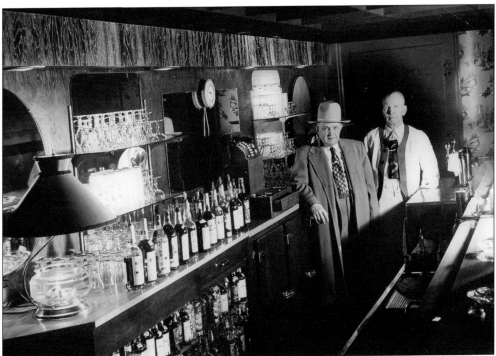

NIFTY'S KAYOIA BAR. Ray Smyser is the man in the hat with an unidentified bartender at the Kayoia Bar in the Nifty Restaurant. After Roger Shannon retired from Texaco, his son, Rand Shannon, took over as superintendent, and he remembers the Nifty Restaurant and the Kayoia Bar. (Courtesy of the Southwest Seattle Historical Society.)

Available

Entrees

Dinner includes soup or tossed green salad, mashed potato or french fries, vegetable, roll and butter

Breaded Veal Cutlet	4.50	Rib Eye Steak (8oz.)	7.50	
Fried Chicken	4.25	Top Sirloin Steak (8oz.)	6.75	
Scallops or Prawns	5.95	Steak Sandwich au jus	5.25	
(When available)		(8 oz. top sirloin)		
Captain's Plate	6.50	Ground Chuck Steak (8oz.)	4.50	
(When available)				

Fish and Chips	3.95	Low-Cal Plate	2.95
Includes cole slaw, roll and butter		Hamburger patty, melted cheese, tomato slices, cottage cheese, rye toast	
Patty Melt	2.95	French Dip	3.65
Hamburger patty and melted American cheese on rye toast		Layers of roast beef on French bread. Choice of tossed salad or french fries	
		With Salad and fries	4.05
Clubhouse	4.10	Nifty Reuben	3.60
Turkey, bacon, lettuce and tomato double-decked on toast. Potato salad		Corned beef, Swiss cheese and sauerkraut grilled on rye bread and served with potato salad	
Denver Sandwich	3.95	Shipwreck	3.65
2 scrambled eggs, ham, green pepper, onion. Served open-faced on toast, with french fries		Barbecued beef on a toasted bun, served with french fries	
Hot Beef Sandwich	3.25	Lo-Cal Steak Plate	5.25
Roast beef and succulent brown gravy served open-faced with mashed potatoes and vegetable		8 ounces top sirloin steak, tomato slices, cottage cheese, rye toast	

Side Orders

French fries	1.10
Potato salad	1.05
Cole slaw	.95
Cottage cheese	1.05
Onion rings	1.30
Mashed potatoes and gravy	.95
Roll and butter	.35
French bread	.60
Vegetable of the day	.95

Salads

Dinner Salad	.95
Chef's Salad	3.90
Strips of ham, turkey, American cheese, Swiss cheese, tomato slices, hard-boiled egg on tossed greens	
Half a Chef's Salad	2.60
Cottage Cheese & Fruit	3.75

Enjoy a Cocktail From our Kayoia Room

NIFTY MENU (INSIDE). The Nifty Restaurant served food 24 hours a day. It served full-course dinners as well as hamburgers and sandwiches. (Courtesy of the Southwest Seattle Historical Society.)

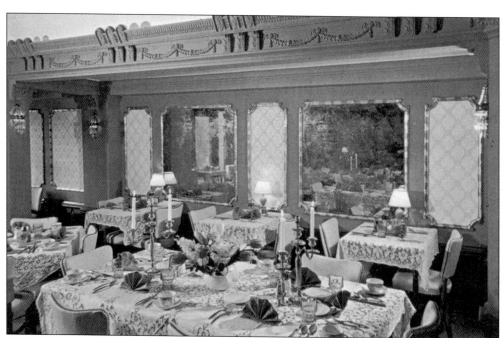

LOWELL DINING ROOM. Herb and Cathie Prior's Lowell Dining Room was located in the Lowell Apartments at Eight Avenue and Spring Street. Herb, who once worked at Boeing, would make his own pot roast (the specialty of the house) and salads. Cathie made the fresh daily pies and waited tables at dinner. (Courtesy of Mary Patterson.)

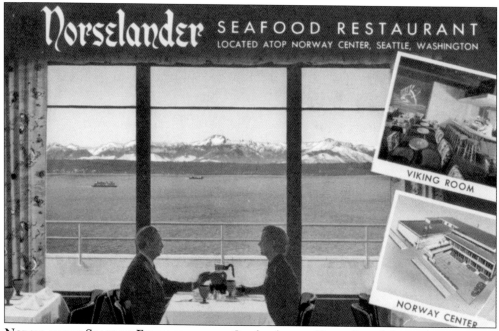

NORSELANDER SEAFOOD EXTRAORDINARY. On the shores of Puget Sound, located at 300 Third Avenue West and Thomas Street atop the Norway Center, was the Norselander Restaurant. This postcard shows a romantic couple, the panoramic view of the Puget Sound, and the snowcapped Olympic Mountains. (Courtesy of John Cooper.)

NORSELANDER MENU. The Norselander Restaurant's menu featured a Viking longship on the front. A martini or Manhattan cost 60¢. A quote from the back of the menu says, "We hope the warmth and hospitality of the Viking Room and the Norselander will make your visit a memorable one—and that you will soon return to enjoy more of our Seafoods Extraordinary." (Author's collection.)

Norselander

COMBINATION ALASKA SHRIMP AND CRAB MEAT LOUIE
Bread Butter Beverage
 1.95

DINNER
(Price of Entree is for Complete Dinner)

Pineapple, Tomato, Orange or Grapefruit Juice
Combination Seafood or Fruit Cocktail

Clam Chowder, Clam Nectar or Chicken Rice Soup
Tossed Green Salad, Chef's Dressing

SEAFOODS
Broiled Alaska King Crab in Shell, Drawn Butter 3.25
Steamed Nova Scotia Finnan Haddie, Drawn Butter 2.25
Deep Fried Eastern Scallops on Toast 2.65
Pan Fried Fillet of Sole, Tartar Sauce 1.75
Deep Fried Gulf Prawns on Toast, Cole Slaw 2.50
Deep Fried Willapoint Oysters on Toast with Chili Sauce 1.90
Louisiana Prawns a la Norselander with Rice en Casserole 3 00
Crab Meat au Gratin with Steamed Rice, Casserole 2.85
Grilled Fillet of Fresh Northern Halibut, Parsley Butter 2.45
Fillet of Fresh Red Snapper Pan Fried in Butter 1.90
French Fried Tender Alaska Shrimp on Toast, Drawn Butter 2.60
Fillet of Fresh King Salmon, Saute Meuniere, Lemon Wedge 2.50
Cold Kippered King Salmon, Potato Salad, Sliced Tomatoes 1.95
Alaska Shrimp Meat a la Newburg, Toast Points, Casserole 2.25
Abalone Steak Saute a la Orley, Avocado Pate 2.55
Grilled Fresh Alaska Black Cod Steak, Lemon Butter 1.95
Pan Fried Mountain Rainbow Trout, Rasher of Bacon 2.65
Broiled Half Lobster, Drawn Butter 3.25
French Fried Salmon and Halibut Tidbits, Toast, Chili Sauce 1.95

STEAKS, CHOPS AND POULTRY
Baked Sugar Cured Ham, Norselander Sauce 2.75
Roast Prime Rib of Steer Beef au Naturel 3.50
Broiled Choice Tenderloin Steak, Champignon 4.50
Half Spring Chicken Fried in Butter on Toast 2.65
Our Own Ground Round Steak, Bordelaise Sauce 2.75
Grilled Top Sirloin Steak, French Fried Potatoes 4.25
Grilled New York Cut Sirloin Steak, Buttered Mushrooms 4.50
Baked Young Tom Turkey, Savory Dressing, Cranberry Sauce 2.85
Garden Vegetable Whipped Potatoes
Pudding, Ice Cream, Sherbet or Assorted Pies
Coffee, Tea or Milk
Danish Tilsit Cheese with Crackers .25
All prices are our O.P.S. ceiling prices or lower. A list showing our ceiling price for each item is available for your inspection.

Monday, September 1, 1952

NORSELANDER MENU (INSIDE). The menu pictured here was dated September 1, 1952. On the menu was an Alaska shrimp and crab meat Louie for $1.95. Bread and a beverage were included. (Author's collection.)

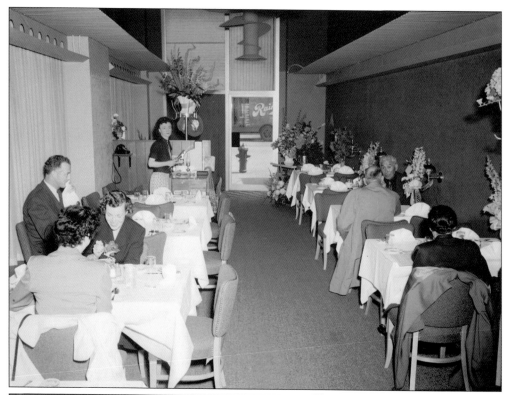

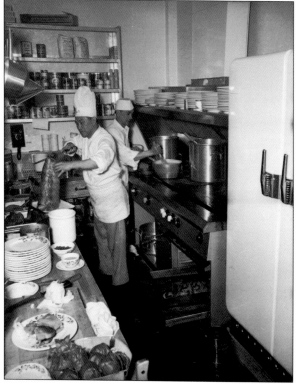

NORTHERN LIGHTS DINING ROOM. This photograph was taken on June 12, 1952, in the Northern Lights dining room, located at 1125 Third Avenue and Seneca Street. The dining room menu included "the Eskimo Legend of the Northern Lights" on the back cover. (Courtesy of the Seattle Municipal Archives, No. 23921.)

NORTHERN LIGHTS KITCHEN. One unidentified chef wearing a tall chef's hat carves a roast, and another unidentified cook whisks in the kitchen at the Northern Lights Restaurant. (Courtesy of the Seattle Municipal Archives, No. 23918.)

PANCHO'S MENU, 1968. Gary Nunn worked at Pancho's for eight years for Kaye Pearl, who bought it from Jim Ward (owner of El Gaucho's). Pancho's had the last moving sign above the street on Fourth Avenue and Stewart Street. The sign was the Pancho's logo on a donkey, and the head of the donkey nodded up and down. (Courtesy of Gary Nunn.)

FROM THE LIVE CHARCOAL BROILER

CHOICE JUICY PRIME RIB, AU JUS	5.95
Extra Cut	7.50

NEW YORK CUT STEAK	6.25
Petite size	4.95
Choice aged steer beef with herb sauce	
FILET MIGNON	6.25
Petite Size	4.95
Choice aged steer beef with herb sauce	
PANCHO'S SHIS-KABOB EN FLAME	5.50
Tender morsels of choice lamb marinated in port wine and exotic herbs, then skewered and broiled	
BROILED LOBSTER TAILS, Drawn Butter	6.75
SURF AND TURF	6.75
One lobster tail and New York or tenderloin steak	
FRENCH LAMB CHOPS	5.95
RACK OF LAMB FOR TWO	13.25
Tossed green salad with above dinners	.75

All above orders are served with king sized baked potato with cheese sauce, bacon, garni and toasted French garlic bread

CHATEAUBRIAND FOR TWO OR DOUBLE CUT NEW YORK STEAK bouquetiere	15.00
Choice cut of beef, broiled to perfection and served on plank with baked potato, mushrooms, onions and garlic French bread	
KING SIZE BAKED POTATO WITH CHEESE SAUCE	.75
ORDER OF WILD RICE	2.00
ORDER OF GARLIC FRENCH BREAD	.50

POTPOURRI

POACHED FILET OF SOLE, with Shrimp Sauce	3.50
CHOPPED SIRLOIN STEAK	3.50
Served with baked potato, sauteed onions, wine sauce	
BROCHETTE OF BEEF TENDERLOIN	5.75
Served with wild rice and mushrooms on flame	
MEDALLIONS OF TENDERLOIN, Bordelaise Sauce	4.25
Baked potato	
BROILED SALMON MEUNIERE	4.50
Baked potato	
CLUB STEAK	3.95
Choice aged steer beef with herb sauce, and baked potato	
NEW YORK STEAK OR PRIME RIB SANDWICH	3.50

PANCHO'S MENU (INSIDE). Pancho's restaurant was not a typical Mexican restaurant, but it did have the first open-pit broiler in Seattle. The restaurant's specialties were broiled steaks and prime rib. It also had its own special French bread called "the Pancho Loaf." (Courtesy of Gary Nunn.)

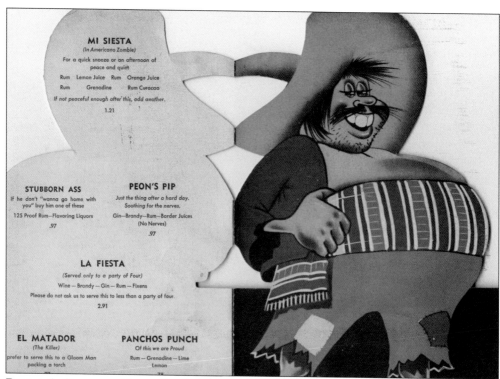

MI SIESTA
(In Americano Zombie)
For a quick snooze or an afternoon of
peace and quiet
Rum Lemon Juice Rum Orange Juice
Rum Grenadine Rum Curacao
If not peaceful enough after this, add another.
1.21

STUBBORN ASS PEON'S PIP
If he don't "wanna go home with Just the thing after a hard day.
you" buy him one of these Soothing for the nerves.
125 Proof Rum—Flavoring Liquors Gin—Brandy—Rum—Border Juices
.97 (No Nerves)
.97

LA FIESTA
(Served only to a party of Four)
Wine — Brandy — Gin — Rum — Fixens
Please do not ask us to serve this to less than a party of four.
2.91

EL MATADOR PANCHOS PUNCH
(The Killer) Of this we are Proud
prefer to serve this to a Gloom Man Rum — Grenadine — Lime
packing a torch Lemon

PANCHO'S COCKTAIL MENU. Pancho's had an enjoyable Mexican decor with waitresses dressed in off-the-shoulder blouses like senoritas. There was music playing in the background, and a charcoal broiler kept the room warm. (Author's collection.)

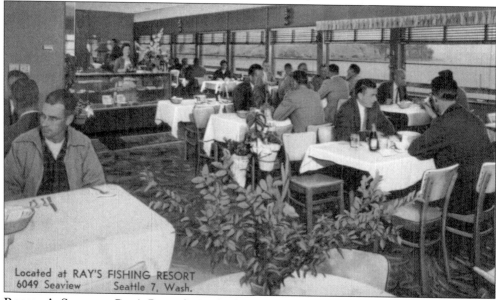

Located at RAY'S FISHING RESORT
6049 Seaview Seattle 7, Wash.

ROSAND'S SEAFOOD CAFÉ. Rosand's Seafood Café was located at Ray's Fishing Resort at 6049 Seaview Avenue. Dorothy and Marvin Rosand built this restaurant entirely over the water, with a spectacular view of the Olympic Mountains. Dorothy's motto was, "Serve the food beautiful and hot!" (Author's collection.)

PLAID PIPER MENU. This is a menu from the Plaid Piper, which was located at 1600 Olive Way. On top of the building was a carriage and hobby horse. Bill Cogswell owned and managed the Plaid Piper. The cocktail lounge had subdued lighting and organ music. (Courtesy of Ed and Colleen Weum.)

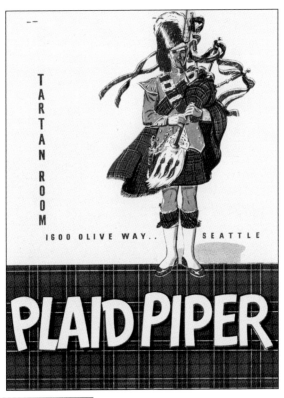

✳ ✳ ✳ *Welcome to the* **PLAID PIPER**

Half Spring Chicken	
on Toast	1.75

PLANKED HAMBURGER STEAK....$1.75
Delicious Steak of Freshly Ground Round
Served on an Oak Plank with Chili Con
Carne, Onion Rings, Spaghetti and
French Fried Potatoes

Salads

Creamy Cottage Cheese with Peach half or Pineapple Slices, Hot Roll	75c
Special Fruit Salad on Crisp Lettuce, Hot Roll	85c
Whole Tomato Stuffed with Tuna or Chicken Salad, Hot Roll	90c
Alaska Shrimp or Crab Leg Salad, Garnished with Sliced Tomatoes, Hard Boiled Egg	1.10

Chef's Salad $1.25

Diced Lettuce, Tomatoes, Celery, Mangos, Julienne
Ham and Cheese, Garnished with Hard Boiled Eggs,
Vinegar, Oil, Salt and Pepper and a *little Oomph!*

Hot Food Specialties

Italienne Spaghetti	$1.00
Half Portion	75c
Served with Bread Stix	
Hot Turkey Sandwich	1.00
(with all the trimmings)	
Hot Beef or Ham Sandwich	90c
(potatoes and gravy)	
Ground Round Steak ½-lb.	1.45
Chicken Fried Cube Steak	1.35
Served with Long Branch Potatoes, Crisp Salad and Hot Roll	

Sandwiches
On Toasted Bun or Bread
☆
Deluxe

Chopped Steak on Toasted Bun With French Fries	85c
Hamburger ¼-lb.	60c
Cheeseburger	70c
Steak Sandwich	1.25
Tuna Fish Salad	50c
Ham or Bacon and Egg	75c
Bacon and Tomato	65c
Ham Fried.... 65c With Cheese.... 75c	
Peanut Butter and Jelly	30c
Egg Fried	35c
Lettuce and Tomato	35c
Grilled Nippy Cheese	40c
Baked Ham	65c
Club House Sandwich	1.25
French Fried Potatoes	25c
Hot Turkey Sandwich	1.00

from our Grill

Little Thin Hot Cakes or Waffles	35c
with Bacon	75c
with 2 Fried Eggs	75c
with Fried Ham	1.00
Ham and Eggs	1.25
Bacon and Eggs	1.25
2 Eggs any style	65c
(potatoes included)	

PLAID PIPER MENU (INSIDE). Shown here is the inside of the lunch menu, featuring sandwiches, salads, and breakfast items, along with other choices. On the dinner menu was the restaurant's specialty, grilled crab legs. Just inside the entrance was a refrigerated case that displayed the homemade pies. (Courtesy of Ed and Colleen Weum.)

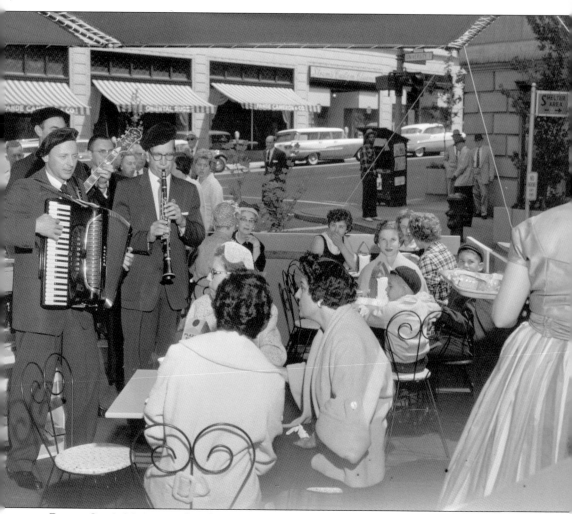

PLAZA CAFÉ. Musicians played at the Plaza Sidewalk café in this photograph dated 1959. The Plaza Café was located in the middle of University Street between Fourth and Fifth Avenues, on the site of the World War II Victory Square. (Courtesy of the *Seattle Post-Intelligencer* Collection, MOHAI, No. 1986.5.11387.2.)

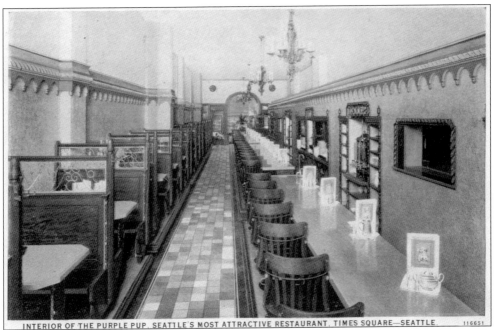

INTERIOR OF THE PURPLE PUP. SEATTLE'S MOST ATTRACTIVE RESTAURANT, TIMES SQUARE—SEATTLE. 116651

THE PURPLE PUP RESTAURANT INTERIOR. This postcard states, "Seattle's Most Attractive Restaurant, Times Square, Seattle." It was located in the Medical-Dental Building. The Depression choked the life out of the Purple Pup, and it closed. In 1932, Walter Clark acquired the space and opened Clark's Coffee Tavern. (Author's collection.)

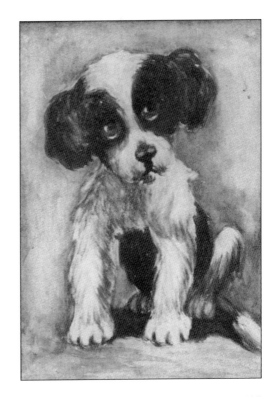

COLEGROVE'S PURPLE PUP MENU. The cover of the Purple Pup menu is seen at right. (Author's collection.)

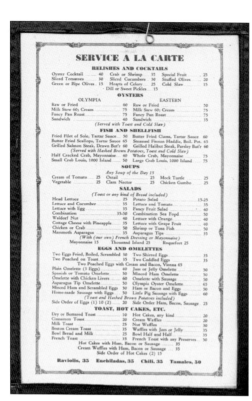

COLEGROVE'S PURPLE PUP MENU (INSIDE). The a la carte menu offered a crab or shrimp cocktail for 35¢. A salad was available, but the dressing was an additional cost (Roquefort 25¢). (Author's collection.)

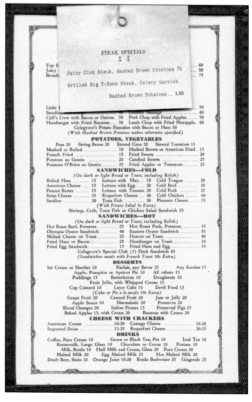

COLEGROVE'S PURPLE PUP MENU (INSIDE). The dinner menu, featured at right, has two steak specials, "Juicy Club Steak and Hashed Brown Potatoes for 75¢ or a Grilled Big T-Bone Steak, Celery Garnish, and Hashed Brown Potatoes for $1." (Author's collection.)

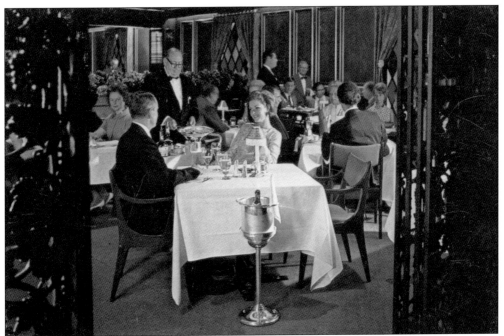

ROSELLINI'S FOUR-10 RESTAURANT. The above postcard shows the inside of Rosellini's Four-10 restaurant. Victor Rosellini became known as Seattle's premiere host and founded a string of famous and successful restaurants in downtown Seattle. He opened Rosellini's 610 in 1950, and Rosellini's Four-10 in 1956. The dining rooms and bars were filled with the most influential and powerful people for nearly four decades. In 1988, Rosellini closed his Rosellini's Four-10. (Courtesy of John Cooper.)

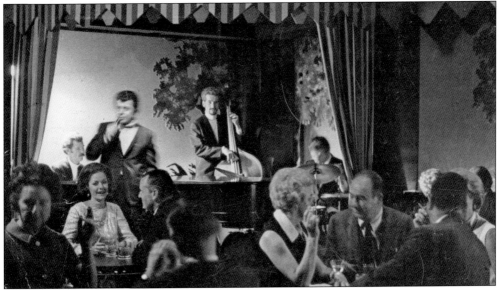

ROSELLINI'S BOULEVARD ROOM LOUNGE. Pictured is the Seattle nightlife in the Boulevard Room Lounge. The lounge offered a collection of rare whiskeys, and wall racks offered a large variety of wines. The room was decorated with world travel posters and gas lamps from Copenhagen. (Courtesy of John Cooper.)

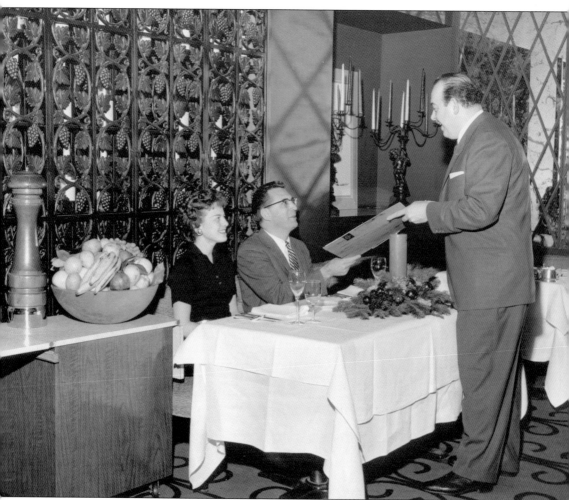

ROSELLINI'S FOUR-10 RESTAURANT INTERIOR. This is a 1959 photograph of Victor Rosellini (1915–2003) beaming over his guests as he offers a menu to Jack Dierdorff and Mrs. Joseph Miccio. A unique wine rack forms a wall in the restaurant, which is located in the White-Henry-Stuart Building at 410 University Street, across from the Olympic Hotel. Magnificent candelabras highlight the sophisticated charm and continental decor of the Terrace Room. (Courtesy of the *Seattle Post-Intelligencer* Collection, MOHAI, No. 1986.5.11398.1.)

ROSELLINI'S FOUR-10 MENU. The oversized Rossellini's Four-10 menu featured a continental cuisine. Victor Rosellini's brother, John Pogetti, was the chef. This restaurant opened without a lunch counter but instead offered a "directors table." A director's table is a large table where single customers are seated with other customers instead of at a lunch counter. (Author's collection.)

Selective Dinner

THE PRICE OF ENTREE DETERMINES COST OF COMPLETE DINNER

Hors D'Oeuvres Four-10		Cracked Crab

Tossed Green Salad

Soup Du Jour

Veal Cutlet, Cordon Bleu	4.90	Boneless Cornish Chicken *Stuffed with Wild*	
Veal Sweetbreads, Financiere	4.90	Boneless Squab Stuffed with Wild Rice	
Veal Kidney Flambe au Fin Cognac	5.25	Calf's Liver, Saute	
Scaloppini of Veal, Marsala	4.90	Tournedos de Boeuf Rossini	
Half Spring Chicken, Charcoal Broiled	4.35	Beef Stroganoff	
Broiled Brochette of Chicken Livers, Wild Rice	5.00	New York Cut Sirloin Steak, *Charcoal Broil*	
Supreme (Breast) of Chicken, Dore Kiev	5.00	Double French Lamb Chops, *Charcoal Broile*	
Supreme (Breast) of Chicken *under Glass, Eugenie*	5.75	Fresh Rainbow Trout, Belle Meuniere	
Chicken Saute Sec aux Champignons	4.75	Rex Sole Saute, Amandine	
Whole Roast Chicken *(For Two) per person*	4.90	Broiled Filet Salmon, Maitre d'Hotel	
		Broiled California Whole Lobster	

Coffee

Assorted Cheese	Banana Fritters	Sabayon Glace
Sherbet Four-10		Ice Cream Four-10

From Our Charcoal Broiler

Half Spring Chicken	2.75	New York Cut Sirloin *(For Two)*	
Brochette of Chicken Livers on Wild Rice	3.50	Planked New York Cut—	
Double French Lamb Chops	4.50	Sirloin Bouquetiere *(For Two)*	
Filet Mignon	5.25	Chateaubriand *(For Two)*	
New York Cut Sirloin Steak	5.25	Chateaubriand Bouquetiere *(For Two)*	
Sauce Bordelaise	.85	*Sauce Bernaise*	.85

Les Specialite's de la Maison

Veal Cutlet Cordon Bleu	3.50	Supreme (Breast) of Chicken, Dore Kiev
Veal Sweetbreads Saute Financiere	3.50	Supreme (Breast) of Chicken *Under Glass, Eu*
Veal Kidney Flambe au Fin Cognac	4.00	Chicken Saute Sec aux Champignons
Scaloppine of Veal, Marsala	3.50	Whole Roasted Spring Chicken *(For Two)*
Tournedos de Boeuf Rossini	4.75	Fettucini al Burro

ROSELLINI'S FOUR-10 MENU (INSIDE). This oversized menu featured items such as New York cut sirloin for two for $11, planked New York cut for two for $13, Chateaubriand for two for $11.50, and Chateaubriand Bouquetiere for two for $13.50. (Author's collection.)

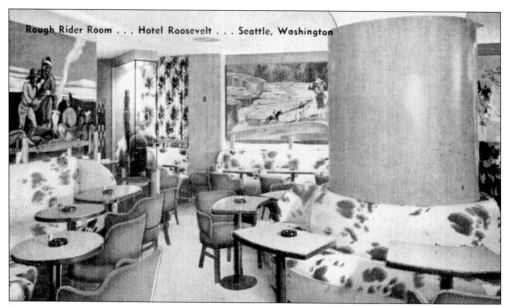

ROUGH RIDER ROOM LOUNGE. Written on the back of this postcard was "the Rough Rider Room is one of the Northwest's most distinctive lounges. A new touch of the Old West gives the Utmost in Comfort and Relaxation." Located in the Hotel Roosevelt at Seventh Avenue and Pine Street, this lounge had pony-hide patterns on the seats, and the waitresses and bartenders wore Western costumes. (Author's collection.)

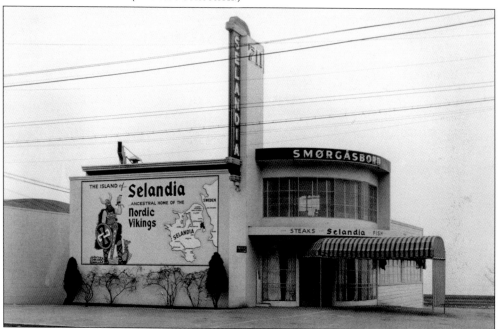

SELANDIA RESTAURANT, 1948. Thematic restaurants reflected the Scandinavian roots of some Seattle natives, as in the Selandia Restaurant and its cousin, the Norselander Restaurant. The Selandia, a smorgasbord, was located at 711 Elliott Avenue West. The signs in the photograph read, "The Island of Selandia—Ancestral Home of the Nordic Vikings. Smorgasbord, Steaks, Fish." (Courtesy of PEMCO Webster and Stevens Collection, MOHAI, No. 1983.10.16743.)

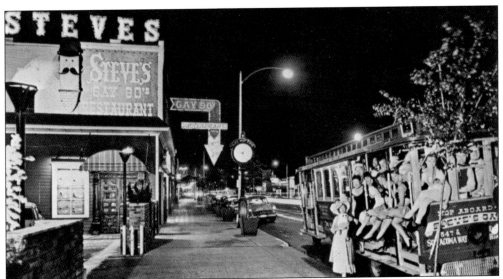

STEVE'S GAY NINETIES. In South Tacoma, Steve's Gay Nineties Restaurant and Smorgasbord opened in 1941 with its historic theme and cancan dancers. They used a San Francisco cable car to transport convention groups and parties to this tourist spot. In 1977, Steve's Gay Nineties Restaurant closed. (Courtesy of Gary K. Nunn.)

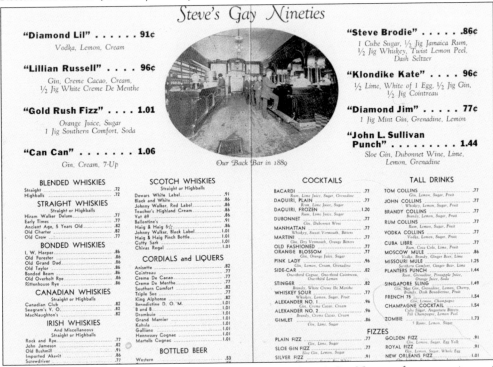

Steve's Gay Nineties

"Diamond Lil" 91¢
Vodka, Lemon, Cream

"Lillian Russell" 96¢
Gin, Creme Cacao, Cream,
½ Jig White Creme De Menthe

"Gold Rush Fizz" 1.01
Orange Juice, Sugar
1 Jig Southern Comfort, Soda

"Can Can" 1.06
Gin, Cream, 7-Up

Our Back Bar in 1889

"Steve Brodie"86¢
1 Cube Sugar, ½ Jig Jamaica Rum,
½ Jig Whiskey, Twist Lemon Peel.
Dash Seltzer

"Klondike Kate" 96¢
½ Lime, White of 1 Egg, ½ Jig Gin,
½ Jig Cointreau

"Diamond Jim" 77¢
1 Jig Mint Gin, Grenadine, Lemon

**"John L. Sullivan
Punch" 1.44**
Sloe Gin, Dubonnet Wine, Lime,
Lemon, Grenadine

BLENDED WHISKIES		SCOTCH WHISKIES		COCKTAILS		TALL DRINKS	
Straight	.72	*Straight or Highball*		BACARDI	.77	TOM COLLINS	.77
Highballs	.72	Dewars White Label	.91	*Rum, Lime Juice, Sugar, Grenadine*		*Gin, Lemon, Sugar, Fruit*	
		Black and White	.86	DAQUIRI, PLAIN	.77	JOHN COLLINS	.77
STRAIGHT WHISKIES		Johnny Walker, Red Label	.86	*Rum, Lime Juice, Sugar*		*Whiskey, Lemon, Sugar, Fruit*	
Straight or Highballs		Teacher's Highland Cream	.86	DAQUIRI, FROZEN	1.20	BRANDY COLLINS	.77
Hiram Walker Deluxe	.77	Vat 69	.86	*Rum, Lime Juice, Sugar*		*Brandy, Lemon, Sugar, Fruit*	
Early Times	.77	Ballentine's	.91	DUBONNET	.77	RUM COLLINS	.77
Ancient Age, 5 Years Old	.82	Haig & Haig 5 ½	.86	*Gin, Dubonnet Wine*		*Rum, Lemon, Sugar, Fruit*	
Old Charter	.82	Johnny Walker, Black Label	1.01	MANHATTAN	.77	VODKA COLLINS	.77
Old Crow	.77	Haig & Haig Pinch Bottle	1.01	*Whiskey, Sweet Vermouth, Bitters*		*Vodka, Lemon, Sugar, Fruit*	
		Cutty Sark	1.01	MARTINI	.77	CUBA LIBRE	.77
BONDED WHISKIES		Chivas Regal	1.01	*Gin, Dry Vermouth, Orange Bitters*		*Rum, Coca Cola, Lime, Fruit*	
I. W. Harper	.86			OLD FASHIONED	.77	MOSCOW MULE	.86
Old Forester	.86	**CORDIALS and LIQUERS**		ORANGE BLOSSOM	.77	*Vodka, Brandy, Ginger Beer, Lime*	
Old Grand Dad	.86			PINK LADY	.96	MISSOURI MULE	1.25
Old Taylor	.86	Anisette	.82	*Gin, Lemon, Cream, Grenadine*		*Southern Comfort, Ginger Beer, Lime*	
Bonded Beam	.86	Cointreau	.77	SIDE-CAR	.82	PLANTERS PUNCH	1.44
Old Overholt Rye	.86	Creme De Cacao	.77	*Overthird Cognac, One-third Cointreau,*		*Rum, Grenadine, Pineapple Juice,*	
Rittenhouse Rye	.86	Creme De Menthe	.77	*One-third Lemon*		*Orange Juice, Soda*	
		Southern Comfort	.82	STINGER	.82	SINGAPORE SLING	1.49
CANADIAN WHISKIES		Triple Sec	.77	*Brandy, White Creme De Menthe*		*Gin, Sloe Gin, Grenadine, Lemon, Cherry,*	
Straight or Highballs		King Alphonse	.82	WHISKEY SOUR	.77	*Brandy, Dash Benedictine, Fruit*	
Canadian Club	.82	Benedictine D. O. M.	1.01	ALEXANDER NO. 1	.96	FRENCH 75	1.54
Seagram's V. O.	.82	B and B	1.01	*Whiskey, Lemon, Sugar, Fruit*		*Gin, Lemon, Champagne*	
MacNaughton's	.82	Drambuie	1.01	ALEXANDER NO. 2	.96	CHAMPAGNE COCKTAIL	1.54
		Grand Marnier	1.01	*Brandy, Creme Cacao, Cream*		*Cube Sugar, Angostura Bitters,*	
IRISH WHISKIES		Kahlua	1.01	GIMLET	.86	*Fill Champagne, Lemon Peel*	
And Miscellaneous		Galliano	1.01	*Gin, Lime, Sugar*		ZOMBIE	1.73
Straight or Highballs		Hennessey Cognac	1.01			*5 Rums, Lemon, Sugar*	
Rock and Rye	.77	Martells Cognac	1.01	PLAIN FIZZ	.77	**FIZZES**	
John Jameson	.82			*Gin, Lime, Sugar*		GOLDEN FIZZ	.91
Old Bushmill	.91	**BOTTLED BEER**		SLOE GIN FIZZ	.77	*Gin, Lemon, Sugar, Egg Yolk*	
Imported Akavit	.86			*Sloe Gin, Lemon, Sugar*		ROYAL FIZZ	.91
Screwdriver	.77	Western	.53	SILVER FIZZ	.91	*Gin, Lemon, Sugar, Whole Egg*	
						NEW ORLEANS FIZZ	1.01

STEVE'S GAY NINETIES MENU (INSIDE). This menu from Steve's Gay Nineties features an inset of the picture of the back bar. The bar was originally purchased in 1898 for $3,000 for the Red Front Saloon. During Prohibition, the bar was confiscated several times, but in each raid, its beauty and structure kept it from being demolished. In 1928, it was purchased for $50 and moved to Steve's Gay Nineties Restaurant. If that back bar could only talk! (Author's collection.)

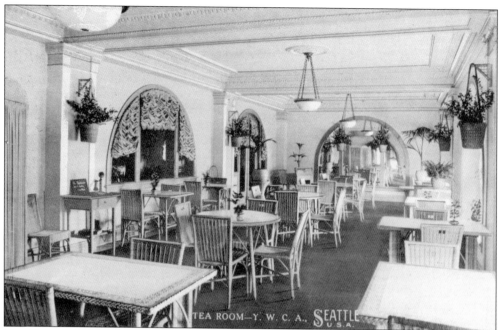

TEA ROOM, YWCA. This early postcard shows the Seattle YWCA Tea Room. To help "the working girl," a group of 28 women in 1894 founded the Seattle YWCA. This YWCA offered 10¢ lunches to working women. A depot matron was hired to meet the trains and steamers to "guard and guide young women traveling alone," as stated in the *Winter Prospectus* 1901–1902. (Courtesy of John Cooper.)

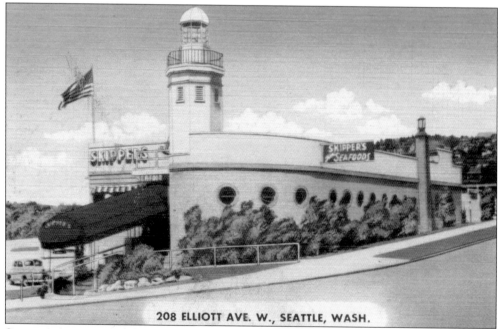

208 ELLIOTT AVE. W., SEATTLE, WASH.

SKIPPER'S SEAFOODS RESTAURANT. The postcard is of the informal Skipper's Seafoods restaurant. The restaurant had a lighthouse and included nautical decor inside such as nets, portholes, ship lights, nautical charts on table tops, and driftwood boards of the *Sea Shanty*. (Author's collection.)

SKIPPER'S MENU. Featured here is a well-loved Skipper's Seafood menu. There were two proprietors—Curt Kremer, a musician, and Ernest Hilsenberg, a magician. Skipper's Seafood received two to three deliveries daily of ocean-fresh seafoods. (Author's collection.)

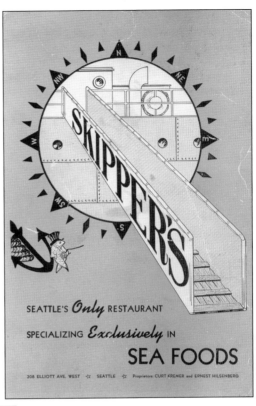

SEATTLE'S *Only* RESTAURANT

SPECIALIZING *Exclusively* IN

SEA FOODS

208 ELLIOTT AVE. WEST ☆ SEATTLE ☆ Proprietors: CURT KREMER and ERNEST HILSENBERG

REGARDING RESERVATIONS — We seat all our patrons in their regular turn. In fairness to all we cannot seat others ahead of customers who are waiting. During rush hours parties of six or more are given preference to the larger tables. During rush hours we seat over 100 patrons per hour.

ENTREES (Continued)

	A La Carte	Full Course Dinners
Olympia Oyster Fry	.80	1.05
Olympia Pepper Pan (Simmered in a highly spiced hot sauce)	.90	1.15
Olympia Plain Pan Roast (Simmered in pure butter)	.90	1.15
Olympia Hangtown Fry	.90	1.15
(Oysters scrambled with Eggs, topped with rashers of Bacon)		
Willapa Oyster Fry	.60	.85
Willapa Pepper Pan (Simmered in a highly spiced hot sauce)	.70	.95
Willapa Plain Pan Roast (Simmered in pure butter)	.70	.95
Willapa Hangtown Fry	.70	.95
(Oysters scrambled with Eggs, topped with rashers of Bacon)		

All of our Oyster Dishes are served in piping hot Griswold Iron Skillets which are both novel and practical. You will enjoy their delicious flavor because the heat is maintained long after serving. This is also true in regard to our Baked Dishes and Newburgs, which are served in individual Dutch Ovens.

Olympic Oysters are the smallest in the world and nationally famous for their exceptional flavor. A native Puget Sound product.

Willapa Oysters are considered one of the finest on the Pacific Coast.

Steamed "Little Neck" Clams with Drawn Butter, Nectar, Rolls	.50	.75
Crab or Shrimp Louie Salad with Hot Rolls	.70	1.00
Half Portion	.45	.75
Cracked Ocean Fresh Crab with Crackers	.75	1.05
Half Portion	.50	.75
Crabmeat Sandwich with French Fries and Cole Slaw	.30	.50
Crab or Shrimp Newburg	.60	.85
(Cream Sauce deliciously flavored with Sherry Wine and Melted Cheese)		
Baked Crab au Gratin	.60	.85
(Baked in Cream Sauce and topped with a generous layer of Melted Cheese)		
Baked "Little Neck" Clams au Gratin	.50	.80
(Baked in Cream Sauce and topped with a generous layer of Melted Cheese)		
French Fried Crablegs	.55	.80
(You will enjoy the delicious flavor of these Jumbo Legs taken from the claw of the crab)		
French Fried Prawns (These are the famous Louisiana Giant Shrimp)	.75	1.00
Crablegs, Pepper Pan (sauted in highly spiced hot sauce)	.65	.90
Grilled Halibut Steak (We use the finest Deep Sea Halibut in the West)	.50	.75
Grilled Salmon Steak	.50	.75
(Salmon from the Pacific Northwest is famous all over the world, especially recommended to out-of-town guests)		
Grilled Red Snapper (rich in oil and proteins)	.55	.80
Grilled Fillet of Sole (We use only the genuine Ocean Fresh Sole)	.50	.75
Fish and Chips (deep fried Halibut Cheeks, French Fried Potatoes)	.40	.65
(This famous dish was originated in England and served in "pubs" and from wagons in newspaper wrappers containing slices of deep fried Halibut)		
Smoked Oysters, served cold, a real delicacy	.50	.75

MISCELLANEOUS

French Fries .15	Cole Slaw .15	Hot Rolls .10	
Celery and Olives .25; with Entree .15	Sliced Tomatoes .25; with Entree .15		
	Cheddar Cheese and Crackers .15		
Coffee .10; with order .07	Tea .10	Milk .07	Assorted Pies .15
Pound Cake .10	Ice Cream or Sherbets .10		

DRIVE YOUR CAR TO ELLIOTT BAY — TRY SEAFOOD PREPARED THE "SKIPPER" WAY

SKIPPER'S MENU (INSIDE). The Skipper's Seafood menu specialized in seafood, such as Olympia oysters, Willapa oysters, "Little Neck" clams, crab, prawns, halibut, salmon, filet of sole, and snapper. The restaurant was the largest buyer of crab in the United States and served such delicacies as French-fried crab legs and a "Crab Leg Pepper Pot." (Author's collection.)

GARSKI'S SCARLET TREE MENU. Built in the Roosevelt neighborhood in 1925, the original restaurant, known as the Wayfair Café, was owned by Lynette Perry. In 1964, Fred Garski bought the restaurant and renamed it Garski's Scarlet Tree, which is the menu pictured here. (Courtesy of Ed and Colleen Weum.)

GARSKI'S

SCARLET TREE

66th and Roosevelt Way
VErmont 7153
Seattle, Washington

DINNERS
FROM 5:00 P.M.

SOUP DU JOUR
TOSSED SALAD, Choice of Dressing
FRENCH FRIED OR BAKED POTATO
FRENCH ROLL
ICE CREAM OR SHERBET
COFFEE, TEA, MILK

RELISH
CARROT STICKS, CELERY, RADISHES,
PICKLES, ONIONS
Per Person .35

SUPREME COCKTAILS
DUNGENESS CRABMEAT
or
ALASKA SHRIMP 1.25

GRILLED HAM STEAK, HONEY BUTTER	2.65
CHOPPED SIRLOIN STEAK, MUSHROOM SAUCE	2.25
CHEF'S TOP SIRLOIN STEAK, MUSHROOM SAUCE	2.75
BREADED VEAL CUTLET, COUNTRY GRAVY	2.35
GRILLED LOIN PORK CHOPS	2.40
ROAST SIRLOIN OF BEEF, AU JUS	2.75
ROAST YOUNG TOM TURKEY, CRANBERRY SAUCE, CELERY DRESSING	2.25
BROILED NEW YORK CUT SIRLOIN STEAK, FRENCH FRIED ONIONS	4.50
BROILED TOP SIRLOIN STEAK, FRENCH FRIED ONIONS	3.90
UNJOINTED HALF SPRING CHICKEN	2.50
DEEP FRIED WILLIPA OYSTERS, COLE SLAW	2.00
DEEP FRIED LOUISIANA PRAWNS, COLE SLAW	2.25
GRILLED KING SALMON, LEMON WEDGE	2.25
CAMEMBERT, LEIDERKRANZ, ROQUEFORT CHEESE	.50

A LA CARTE

BROILED LOBSTER TAIL, FRENCH FRIED POTATOES, FRENCH ROLL	2.75
CREAMED CRABMEAT EN CASSEROLE	1.75

ITALIAN SPAGHETTI WITH MEAT SAUCE, GARLIC BREAD	1.50
ITALIAN SPAGHETTI WITH RAVIOLA, GARLIC BREAD	1.75

COFFEE, TEA, MILK, BUTTERMILK	.15

NO SERVICE UNDER .25

GARSKI'S SCARLET TREE MENU (INSIDE). Garski's Scarlet Tree was located in a one-story, brick-clad building at Sixty-sixth Avenue and Roosevelt Way. They opened for dinner at 5:00 p.m. and once served broiled lobster tail, French-fried potatoes, and a French roll for $2.75. (Courtesy of Ed and Colleen Weum.)

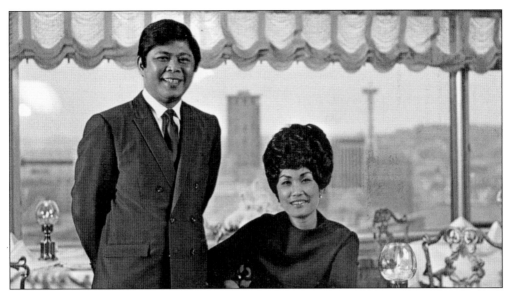

Top O' the Town. This postcard is of the Top O' the Town restaurant. Stated on the back of the menu was, "From this very same hill location, early pioneers watched for the flickering lights of distant sailing ships coming from the Eastern colonies, via the treacherous Cape Horn . . . 120 days from the Barbados . . . 140 days from New York . . . and loaded to the gunnels with quilled-penned mail, bolts of calico, kegs of Irish whiskey . . . and the Mercer girls!" (Courtesy of Mary Patterson.)

Top O' the Town Menu. Just outside Seattle's downtown, at the corner of Madison Street and Terry Avenue, the Sorrento Hotel opened on First Hill in 1908. Several hotels had been built just outside Seattle's downtown area. Sorrento advertised itself as "a hotel in the heart of things." The Sorrento Hotel housed a rooftop restaurant, a roof garden, and scenic views of the mountains, the bay, and the Emerald City. (Author's collection.)

117

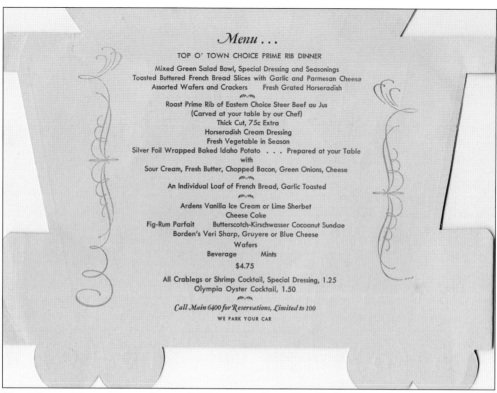

Menu . . .

TOP O' TOWN CHOICE PRIME RIB DINNER

Mixed Green Salad Bowl, Special Dressing and Seasonings
Toasted Buttered French Bread Slices with Garlic and Parmesan Cheese
Assorted Wafers and Crackers Fresh Grated Horseradish

Roast Prime Rib of Eastern Choice Steer Beef au Jus
(Carved at your table by our Chef)
Thick Cut, 75c Extra
Horseradish Cream Dressing
Fresh Vegetable in Season
Silver Foil Wrapped Baked Idaho Potato . . . Prepared at your Table
with
Sour Cream, Fresh Butter, Chopped Bacon, Green Onions, Cheese

An Individual Loaf of French Bread, Garlic Toasted

Ardens Vanilla Ice Cream or Lime Sherbet
Cheese Cake
Fig-Rum Parfait Butterscotch-Kirschwasser Cocoanut Sundae
Borden's Veri Sharp, Gruyere or Blue Cheese
Wafers
Beverage Mints
$4.75

All Crablegs or Shrimp Cocktail, Special Dressing, 1.25
Olympia Oyster Cocktail, 1.50

Call Main 6400 for Reservations, Limited to 100
WE PARK YOUR CAR

TOP O' THE TOWN MENU (INSIDE). This menu from Top O' the Town featured prime rib of Eastern steer beef carved at the table by the chef. Included was a baked potato with all the trimmings, fresh vegetables, garlic French bread, a choice of dessert, and a beverage, all for $4.75. (Author's collection.)

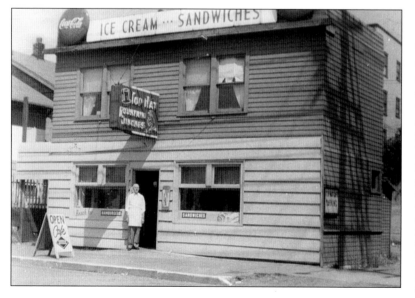

TOP HAT CAFÉ. Owner Carl Torell is standing in the doorway of his Top Hat Café. He and his wife, Elsie, operated the café from 1958 to about 1960. The café was located at 408 Mercer Street in Seattle. (Courtesy of Jerry Torell.)

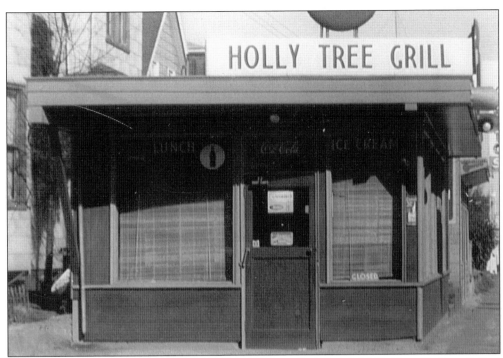

HOLLY TREE GRILL. In the beginning, the grill was called Heidi's Holly Tree Grill until Carl and Elsie Torell took ownership in 1961. They changed the name to Elsie's Holly Tree Grill. It was later shortened to the Holly Tree Grill. (Courtesy of Jerry Torell.)

HOLLY TREE GRILL (INSIDE). Shown in this photograph is Elsie Torell at her Holly Tree Grill, located at 2 West Howe Street in Seattle. Jerry Torell said that Carl and Elsie Torell had an excellent business as well as a great love for one another. (Courtesy of Jerry Torell.)

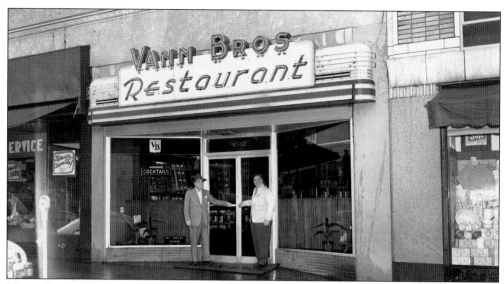

VANN BROTHERS RESTAURANT. Pictured is the Vann Brothers Restaurant, located at 4542 California Avenue, on March 1, 1952. Leonard Vann said, "We served real veal cutlets, the type of food that people would come clear from Issaquah or the north end on a regular basis to have. We were a neighborhood restaurant and depended on repeat trade to make it. My dad and uncle started the business under the premise that if we would serve good food, keep the place clean, and give good service at moderate prices, people are going to come back. And that's basically what happened." (Courtesy of the Seattle Municipal Archives, No. 23351.)

VANN BROTHERS MENU. Pictured here is a menu from the Vann Brothers Restaurant. "Back in 1922, Vann Brothers was originally located in the Admiral District on the present grounds of the Safeway Store at Admiral Way, across the street from Lafayette Grade School. The reason it was located there was because it was in close proximity to the high school," said Leonard Vann, the son of one of the Vann brothers. (Author's collection.)

Vann Brothers Menu (Inside).
Leonard Vann also remembered that, "To begin with it was not a restaurant; it was just a place for the young folks at West Seattle High School to gather and had kind of a gym effect. It also had a soda fountain, candy bars, and so forth, for the kids to gather. And it wasn't until approximately a year later that my grandmother started to cook roasts and hams and so forth. My cousin and my dad's younger brother were going to school across the street at Lafayette. He'd go home for lunch. Then with his little wagon, he'd bring the meat, the roasts, the hams and what not, up to the restaurant. They would slice them and serve sandwiches and that was the beginning of starting to serve food. Four generations of Vann's, including my grandmother, worked there." (Author's collection.)

A La Carte Menu

SALADS

Assorted Fruit Plate	75	Combination, Half 45; Whole	80
Pineapple and Cottage Cheese Salad	60	Fruit Salad	70
Tuna Fish Salad	75	Crab Salad	75
Cold Dutch Lunch	60	Shrimp Salad	75
Lettuce and Tomato	60	Crab Louis	75
Hearts of Lettuce	35	Shrimp Louis	75
Sliced Tomatoes	50		

Bread and Butter served with Salads

SANDWICHES

Hamburger Sandwich on Toasted Bun	25
Fried Ham and Egg or Bacon and Egg Sandwich	50
Fried Ham or Bacon Sandwich	40
Denver Sandwich	45
Fried Ham or Bacon and Tomato Sandwich	50
Fried Egg or Egg Salad Sandwich	25
Swiss or American Cheese Sandwich	25
Peanut Butter and Jelly Sandwich	25
Grilled Cheese Sandwich	30
Melted Cheese Sandwich on Toast	35
Liverwurst, Bologna or Salami Sandwich	25
Lettuce and Tomato Sandwich	30
Tuna Fish Sandwich	35
Grilled Tuna Fish Sandwich	40
Cold Roast Beef Sandwich 40; Hot	50
Cold Sliced Chicken or Turkey Sandwich 60; Hot	75
Cold Baked Ham Sandwich 45; Hot	55
Cold Pork Sandwich 45; Hot	55

Sandwiches on Toast 5c Extra

Special Cube Steak, French Fries	1.00
Special Cube Steak Sandwich, French Fries	80

Served In due respect for those waiting, please vacate Booths as soon as possible

Cocktails . . .

VANN BROS.
4542 California Avenue

Vann Brothers Cocktail Menu. "I attribute our success through the generations to the fact that family members are in management and there practically around the clock. They were on top of things and would see that things were kept up and done. They were meticulous in keeping the standards that my dad and uncle had established. Also, our help was just super. We had a waitress who retired after 32 years with us, and a bartender who retired after 25 years with us. You don't keep people that long unless you treat them right," Leonard Vann said when talking with the Southwest Seattle Historical Society's Jon Lee Joseph in 1999. (Author's collection.)

COCKTAIL MENU

Bar Whiskey (straight shot)	.50
7-Up Hi-Ball	.50
Gingerale Hi-Ball	.50
Coke Hi-Ball	.50
Moose Milk Hi-Ball	.70
Moscow Mule Hi-Ball	.70
Cuba Libre	.60
Wines (by glass)	.15 and .30
Western Beer (bottle)	.25
Eastern Beer (bottle)	.30
Draft Beer	.10
Brandy	.70
Bacardi - Silver Rum	.55
Hudson Bay Demerara Rum	.80
Smirnoff Vodka	.55

Tall, Cool Thirst Quenchers

Tom Collins	.60
John Collins	.60
Rum Collins	.60
Vodka Collins	.60
Gin Fizz	.55
Silver Fizz	.65
Golden Fizz	.65
Royal Fizz	.65
Ramos Fizz	.70
Waldorf Fizz	.70
Gin Daisy	.55
Planter's Punch	.80
Zombie	1.30
Singapore Sling	.80
Whiskey Sour	.55

Hot Drinks

Hot Buttered Rum	.65
Cafe Royal	.60
Coffee Royal	.60
Hot Toddy	.65
Tom & Jerry (in season)	.70

Before Dinner Cocktails

Dubonnet Cocktail	.55
Gibson Cocktail	.55
Gimlet Cocktail	.55
Manhattan Cocktail	.55
Martini Cocktail	.55
Rob Roy	.70
Zazarac	.65
Old Fashion	.55
Swiss Swissesse	.70
Vodka Martini	.60

After Dinner Drinks

Alexander	.80
Angels Kiss	.55
B & B	.80
Bacardi (plain or frozen)	.60
Between the Sheets	.80
Clover Club	.70
Daiquiri (plain or frozen)	.55
French 75 m.m.	1.50
Jack Rose	.55
Orange Blossom	.60
Pink Lady	.70
Side Car	.80
Stinger	.80
Stingeree	.80
Ward Eight	.65
Grass Hopper	.90
Pousse Cafe	1.05
King Alphonse	.55
Vann Brothers' Dream	.65

Whiskies

BONDED BOURBONS

Old Crow	.70
Old Grand Dad	.70
Old Taylor	.70
Old Forester	.70
Kentucky Tavern	.70
I. W. Harper	.70

RYE WHISKEY

Hallers	.55
Old Overholt	.70
Old Crow	.70

BLENDS

Seagram's 7-Crown	.50
Calverts	.55
Four Roses	.55
Walker's Imperial	.50

STRAIGHT BOURBONS

Ancient Age	.60
Old Charter	.60
Early Times	.60
Walkers Deluxe	.60

CANADIAN WHISKEY

Seagram's V. O.	.70
Canadian Club	.70

SCOTCH

Two Seal	.65
Teachers	.70
Black & White (White Label)	.70
Vat "69"	.70
White Horse	.70
Johnny Walker (Red Label)	.70
Johnny Walker (Black Label)	.80
Haig & Haig Pinch	.80

IRISH WHISKEY

Old Bushmills	.75
John Jameson	.70

All Above Prices Include Washington State Sales Tax

VANN BROTHERS COCKTAIL MENU (INSIDE). Stamped on the Vann Brothers cocktail menu was, "All prices are our OPS ceiling prices or lower. A list showing our ceiling price for each item is available for your inspection." (Author's collection.)

VON'S RESTAURANT. Von's Rabbit approaches a family dining at Von's Restaurant on Easter, March 29, 1959. Notice the Kalakala ferry painting behind the diners. Von's Restaurant had a menu with more than 300 items served 24 hours a day. Located at 1423 Fourth Avenue, Von's historic restaurant survived Prohibition and is still open. (Courtesy of the Robert H. Miller Collection, MOHAI, No. 2002.46.26.)

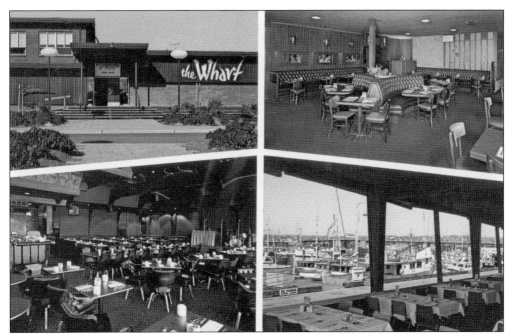

THE WHARF RESTAURANT. This postcard shows the Wharf Restaurant that was located at Fisherman's Terminal at the south end of Ballard. There was a restaurant, banquet room, coffee shop, and two cocktail lounges. (Author's collection.)

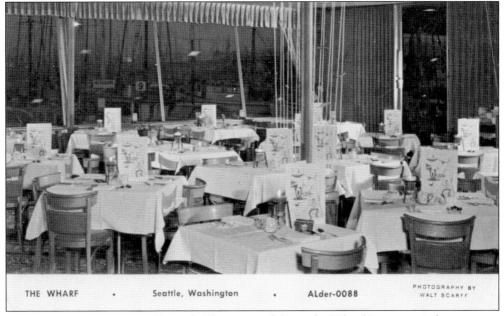

THE WHARF • Seattle, Washington • ALder-0088 PHOTOGRAPHY BY WALT SCARFF

THE WHARF RESTAURANT (INSIDE). This postcard shows the Wharf Restaurant's dining room, which was located at 1735 West Thurman Street. Notice the menus on the tables. Plate-glass windows allowed diners a full-length view of the fishing fleets outside, a benefit of being on the wharf. (Author's collection.)

THE WHARF MENU. Pictured here is the oversized dining menu from the Wharf Restaurant. Approximately two-thirds of the building was the main dining room, with the adjoining lounge called the Mermaid Room. There was an inviting fireplace and saltwater fish tanks with sea horses and starfish. (Author's collection.)

THE WHARF MENU (INSIDE). Fresh fish was always a favorite at the Wharf Restaurant. It also had daily specials. Monday's special was corned beef, Tuesday braised tips, Wednesday lamb shanks, Thursday short ribs, and Friday pot roast. (Author's collection.)

AFTER 5:00 P. M.

From Our Charcoal Broiler
"THE WAY YOU LIKE IT"

	A La Carte	Course Dinner
Cubed Top Round Steak with Country Gravy	1.25	2.25
Chopped Sirloin Steak with French Fried Onion Rings	1.25	2.25
Prime Top Sirloin Steak 12 ounce, with Mushroom Sauce	3.25	4.25
New York Cut Steak 12 ounce, with Mushroom Sauce	3.50	4.50
Filet Mignon 9 ounce, with Special Sauce	3.50	4.50
Broiled Lamb Chops with Mint Jelly	1.75	2.75

	A La Carte	Course Dinner
Half Spring Chicken Pan Fried to Order	1.75	2.75
Breaded Cutlets of Veal with Country Gravy	1.25	2.25
DeLuxe Ham and Eggs with Hashed Browned Potatoes	1.25	2.25

Sea-food Plate, Wharf Style

Northern Halibut, King Salmon, Willapa Oyster,
Louisiana Prawns, Eastern Scallops and
Dungeness Crab Legs

Tartar Sauce Lemon Wedge
Cole Slaw

A La Carte Dinner
$1.65 $2.65

☆

Fish and Chips, Northwest Style

Cole Slaw Tartar Sauce

A La Carte Dinner
$.75 $1.75

☆

DINING ROO[M]
COURSE DINNER INCLUDES

Choice of Crab, Shrimp or Fruit Cockt[ail]
or Grapefruit or Tomato Juice
Chowder, Nectar or Soup Du Jour
Dinner Salad
Pudding, Jell-O, Ice Cream or Sherb[et]
Coffee or Milk

Fish

	A La Carte
King Salmon Steak	1.30
Northern Halibut Steak	1.30
Filet of Sole, Deep Fried	.90
Filet of Red Snapper California Style	.90
Brook Trout, Pan Fried	1.50

Clams

Steamed Clams with Nectar and Drawn Butter, Cole Slaw	1.25
Razor Clams, Pacific Beach Style	1.25
Abalone Steak	1.75

Oysters

Willapa Oysters, Fried, Small and Tasty	1.15
Willapa Oyster Sandwich	.90
Willapa Oyster Stew with Milk	.90
with Half and Half	1.10
Willapa Oyster Fancy Pan Roast	1.25
Olympia Oysters (Pan Fried)	2.25
Olympia Oyster Stew with Milk	2.15
with Half and Half	2.35
Olympia Oyster Fancy Pan Roast	2.25

Shell Fish

Barbecued Louisiana Prawns, Steamed Rice	1.35
Deep Fried Louisiana Prawns	1.35
Alaska Shrimps à la Newburg	1.50
Curried Shrimps with Fluffy Rice	1.50
Whole Cracked Crab	1.75
Half Cracked Crab	1.00
Large Crab Legs, Deep Fried	1.75
Crab Newburg en Casserole	1.50
Deep Fried Eastern Scallops, Cocktail Sauce	1.35
Half Lobster, Broiled	2.25

Smoked and Salt Fi[sh]

THE WHARF MERMAID MENU. A favorite hangout was the Mermaid Room, with its subdued lighting, deep-cushioned chairs, and organ music. Another bar in the Wharf Restaurant was the Moby Dick, where the drinks were cheaper and the local guys from the fishing boats hung out. (Author's collection.)

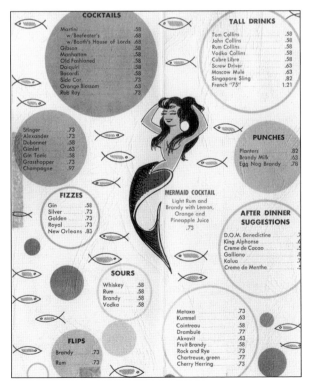

COCKTAILS				TALL DRINKS	
Martini	.58			Tom Collins	.58
w/Beefeater's	.68			John Collins	.58
w/Booth's House of Lords	.68			Rum Collins	.58
Gibson	.58			Vodka Collins	.58
Manhattan	.58			Cubre Libre	.58
Old Fashioned	.58			Screw Driver	.63
Daiquiri	.58			Moscow Mule	.63
Bacardi	.58			Singapore Sling	.82
Side Car	.73			French "75"	1.21
Orange Blossom	.63				
Rob Roy	.73				

				PUNCHES	
Stinger	.73				
Alexander	.73				
Dubonnet	.58			Planters	.82
Gimlet	.63			Brandy Milk	.63
Gin Tonic	.58			Egg Nog Brandy	.78
Grasshopper	.73				
Champagne	.97				

FIZZES			MERMAID COCKTAIL
Gin	.58		Light Rum and Brandy with Lemon, Orange and Pineapple Juice .73
Silver	.73		
Golden	.73		
Royal	.73		
New Orleans	.83		

AFTER DINNER SUGGESTIONS

D.O.M. Benedictine
King Alphonse
Creme de Cacao
Galliano
Kalua
Creme de Menthe

SOURS	
Whiskey	.58
Rum	.58
Brandy	.58
Vodka	.58

Metaxa	.73
Kummel	.63
Cointreau	.58
Drambuie	.77
Akvavit	.63
Fruit Brandy	.58
Rock and Rye	.73
Chartreuse, green	.77
Cherry Herring	.73

FLIPS	
Brandy	.73
Rum	.73

THE WHARF MERMAID MENU (INSIDE). The Mermaid cocktail included light rum and brandy with lemon, orange, and pineapple juices and cost 73¢. The decor included Pacific Northwest paintings and a saltwater fish tank. Art students painted along the wharf, and many locals and tourists visited the Wharf Restaurant and cocktail lounges. (Author's collection.)

INDEX

ACROSS AMERICA, PEOPLE ARE DISCOVERING SOMETHING WONDERFUL. THEIR HERITAGE.

Arcadia Publishing is the leading local history publisher in the United States. With more than 4,000 titles in print and hundreds of new titles released every year, Arcadia has extensive specialized experience chronicling the history of communities and celebrating America's hidden stories, bringing to life the people, places, and events from the past. To discover the history of other communities across the nation, please visit:

www.arcadiapublishing.com

Customized search tools allow you to find regional history books about the town where you grew up, the cities where your friends and family live, the town where your parents met, or even that retirement spot you've been dreaming about.